THE BERENSON ARCHIVE

THE BERENSON ARCHIVE

An Inventory of Correspondence

COMPILED BY NICKY MARIANO

ON THE CENTENARY
OF THE BIRTH OF

BERNARD BERENSON

1865 - 1959

VILLA I TATTI
THE HARVARD UNIVERSITY CENTER
FOR ITALIAN RENAISSANCE STUDIES
FLORENCE, ITALY

DISTRIBUTED BY HARVARD UNIVERSITY PRESS
CAMBRIDGE, MASSACHUSETTS, U. S. A.

1965

Photograph of Bernard Berenson by Emil Schultess,
reproduced by permission of Conzett and Huber, Zürich.

Typography by
Martin Faigel, Guidobaldo Passigli, and Schulim Vogelmann

Library of Congress Catalog Card Number 65-28597

Printed at the
Tipografia Giuntina, Florence, Italy
December 1965

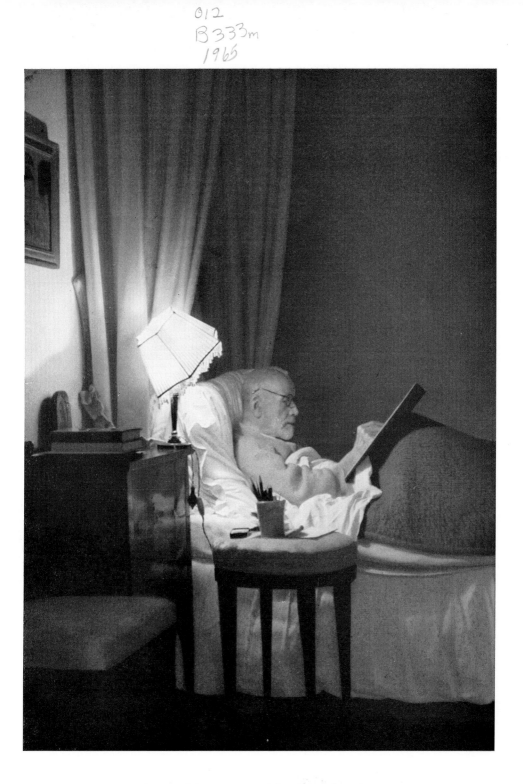

Bernard Berenson writing in bed, 1954

Excerpt from a letter of Bernard Berenson to his wife

PREFATORY NOTE

On Bernard Berenson's death on October 6, 1959, he left his unpublished manuscripts and papers to Nicky Mariano, together with the vast collection of correspondence which had accumulated during the nearly sixty years of his residence at Villa I Tatti. In the year which marks the hundredth anniversary of Berenson's birth, the Harvard University Center for Italian Renaissance Studies, which is now established at I Tatti, takes pleasure in publishing this inventory of the correspondence in order to make available to interested scholars a knowledge of its contents.

The archive is housed in the Biblioteca Berenson in the Villa I Tatti. The library is open to qualified scholars daily from 9:00 to 1:00 and from 2:30 to 6:00 (closed Saturday afternoon and Sunday). Prior authorization for consulting the Berenson correspondence must be secured from Nicky Mariano who has the sole right to grant or withhold access to any letters in the collection. However, permission to publish a letter or to quote a portion thereof must be secured from the writer of the letter or his literary heirs. Thus Nicky Mariano has the right to grant such a permission for the letters of Bernard and Mary Berenson, and of course for those written by herself, but for all other letters authorization must be secured from the writer or his heirs.

Myron P. Gilmore
Director

I Tatti

FOREWORD

At regular intervals B.B. used to make a desperate appeal to have his letters put in order. « Look at these drawers, they are already overflowing. » And I would tease him about his habit of keeping every scrap of paper, even « bread and butter » letters. After his death and before the arrival of the first Director of the new Harvard University Center for Italian Renaissance Studies, when B.B.'s rooms had to be cleared out, I did not have the heart to throw away what he had respected. Besides, I felt that perhaps even the unimportant letters might help to create for future scholars an image of what I used to call B.B.'s « spiderweb » with its threads spun out in every direction.

My faithful and efficient assistant, Fiorella Superbi Gioffredi, accordingly filed all the letters chronologically and stored them in a room which, already in 1954 when a new wing was added to the library, had been set aside and lined with cupboards for housing the whole collection of « Berensoniana »: B.B.'s and Mary's published and unpublished manuscripts, notes, diaries, letters, offprints of articles, surplus volumes of published books, biographical material, and personal photographs.

Early this year Myron Gilmore, the second Director of the Harvard Center, told me of the suggestion made by Michael Rinehart for honoring B.B.'s hundredth anniversary. Michael Rinehart had not only looked after the Berenson library from 1962 to 1964 but knew it intimately from having worked in it for a number of years. He proposed bringing out this check-list of the letters preserved in the Berenson archive. I was delighted and comforted by the thought that half the work had already been done. Again Fiorella Superbi Gioffredi's assistance was invaluable in counting all the letters and preparing a card for each correspondent. These cards were filled out either by me or by Henry Coster, B.B.'s friend and his partner on walks and in learned conversations through many years. He has been very generous in devoting a considerable amount of time to the task. Sometimes he and I could not help laughing at our eagerness in hunting for the death dates of people who turned out to be cheerfully alive. Perhaps two neat dates are more satisfactory than one!

Altogether assembling dates and biographical information has taken

longer than I had foreseen and in spite of all our efforts the final result is not as perfect as I would have wished it to be. Some of the correspondents, especially those belonging to B.B.'s and Mary's early days, remain hidden in a mist of vague information.

My hope is that this small publication may not only help to produce some of the missing information but may also induce B.B.'s correspondents or their descendants to return his letters to the Tatti archives. As B.B. always wrote in longhand and did not keep any copies of his letters (only in his last years did he resign himself to dictating), there was at first only his long intermittent correspondence with his wife and the letters exchanged with me during my holidays. A few additions have been made through the years. Copies of B.B.'s letters to Louis Gillet were sent by his widow, Suzanne Gillet, and the same was done by Zezette Du Bos, Charlie Du Bos' widow, and by Bessie Trevelyan, the widow of the dear old poet. The literary heirs of the « Michael Fields » allowed B.B.'s letters to them to be photostated. Among living friends Edith de Gasparin, Natalie Barney, Patricia Botond, Hamish Hamilton and Daniel Thompson have donated copies of their letters. Quite recently Ralph Curtis, Jr. has had some of B.B.'s letters to his father copied for us and Wolfgang Lotz, the Director of the Hertziana in Rome, has sent us a microfilm of B.B.'s letters to his old friend Ernst Steinmann, who was from its foundation and for many years thereafter the Director of the Hertziana. Others, like the daughter of Frank Jewett Mather, Jr., the daughter of William Ivins, Jr., and Henry Coster himself, have promised to let us have copies of the letters kept by them.

I express my thanks to all these kind past and future donors of letters as well as to all those who have answered the appeals of Henry Coster and myself for biographical information. Walter Muir Whitehill of the Boston Athenaeum read the entire manuscript and supplied additional dates and corrections. I am also grateful to Martin Faigel, successor of Michael Rinehart as Librarian at I Tatti, for his assistance in the work of identification, for his negotiations with the firm of Giuntina on the design of the book, and for preparing the editorial note. Gloria Ramakus, secretary at I Tatti, checked the entire inventory for editorial consistency. The proof-reading was done by Fiorella Superbi Gioffredi, Gloria Ramakus, and Martin Faigel. Finally, I wish to thank Myron Gilmore for accepting Michael Rinehart's suggestion and for making possible this small publication.

San Martino a Mensola Nicky Mariano
April 1965

EDITORIAL NOTE

The reader should bear in mind that this is not a full-scale cata-
logue of the Berenson correspondence but only a check-list, and he
should note the following procedures which were followed in the
work of compilation:

The check-list has been taken from the index of correspondents
made when the I Tatti Archive was put into its present form after
Bernard Berenson's death. Except in rare cases, for purposes of bio-
graphical identification, the index has not been re-checked against the
letters.

All letter-writers and recipients are listed and cross-referenced in
Part One. When a person is known under several names, such as
real and pen name, or because of remarriage, one form has been chosen
for the main entry and the others have been cross-referenced. The
form of entry in *Part One* is as follows: full name, birth and death
dates when known, brief biographical note, initial and terminal dates
of the correspondence, the total of items. Undated letters receive a
separate total. The total makes no distinction between letters, postcards,
and cables. All letters are to Bernard Berenson unless otherwise iden-
tified. Letters to Mary Berenson are described as *To MB* and letters
to Nicky Mariano as *To NM*. All other recipients are identified in full.

Correspondence with members of a firm, unless of a personal nature,
has generally been entered under the firm's name as a single, group
entry. Exceptions have been cross-referenced.

No distinction has been made between original letters and the
variety of copies at I Tatti—handwritten copies, typescript copies, type-
script carbons, photostats and xeroxes of originals, and preliminary
autograph drafts. A plan to distinguish between originals and kinds
of copies by sigilla resulted in a confusion of symbols and had to
be abandoned.

Internal evidence has generally not been used to supply dates
for letters. However, when a date has been supplied, it is not indi-
cated in any way by parentheses or brackets. Letters dated with a
day and month but no year have usually been put in the *No date*
column.

The Archive contains some letters, originals and copies, not ad-
dressed to the Berensons or to Nicky Mariano, which were enclosed

in letters to them or were inherited by them. As an example, there are the twelve letters from Walt Whitman to Robert Pearsall Smith, all copies. They will be found as a main entry in *Part One* under Whitman, with no indication as to whether copies or originals, and with a cross-reference from Smith to Whitman.

For convenience and easy consultation, the letters written by the Berensons and by Nicky Mariano have been separately listed in *Part Two* by recipient. Readers should remember that this is of course by no means a full inventory of their correspondence, which is scattered in the papers of the recipients and letter-writers of *Part One*, but only a record of those letters or copies which are in the I Tatti Archive.

PART ONE

ABBOTT, Senda Berenson, 1866-1954. Eldest sister of Bernard Berenson, wife of Professor Herbert Abbott.
March 20, 1894-January 30, 1954 181
No date 17

ABERCONWAY, Christabel. Wife of Henry Duncan McLaren, Baron Aberconway.
February 4, 1950-December 1950 3

ABRAMS, Harry Nathan, b. 1904. President, Harry N. Abrams, Inc., New York publishers.
October 29, 1954-December 7, 1954 2

ACHESON, Alice Stanley. Wife of Dean Acheson, American statesman.
September 29, 1953-June 20, 1955 2

ACTON, Arthur Mario, 1879-1952. English art collector, father of Harold Mario Acton.
May 25, 1918 1

ACTON, Harold Mario, b. 1904. English writer and historian.
February 27, 1946-November 8, 1958 34

ADAMS, Frederick Baldwin, b. 1910. Director, Pierpont Morgan Library, New York.
August 4, 1950-August 28, 1953 10

ADAMS, Freeman W. American student of history.
February 17, 1946-October 21, 1946 3

ADAMS, Henry, 1838-1918. American historian.
September 26, 1907-March 30, 1915 37

ADAMS, Philip Rhys, b. 1908. American museum director.
March 21, 1955 1

ADLER, Cyrus, 1863-1940. Orientalist and Jewish leader.
February 23, 1932 1

1

AGA-OGLU, Mehmet. Turkish archaeologist and **museum** curator.
January 23, 1929-January 14, 1932 4

AGNEW, Colin, b. 1882. English art dealer.
April 2, 1950-November 17, 1950 5
No date 3

AGNEW, Geoffrey, b. 1908. English art dealer.
October 16, 1950-November 15, 1957 18

AGNEW, Lockett. English art dealer.
October 9, 1912 1

AILES, Edgar H., b. 1905. American lawyer.
July 20, 1949 1

ALAZARD, Jean, 1886-1960. French art historian.
August 20, 1921-December 28, 1951 7

To NM:
December 23, 1950-March 30, 1952 3

ALBA, James Fitz-James Stuart, Duke of Alba and Duke of Berwick,
1878-1953. Writer and member of Royal Spanish Academy.
July 16, 1909-January 21, 1953 56

ALBERTI, Count Guglielmo degli, 1900-1964. Italian writer and
literary critic.
February 25, 1932-December 25, 1945 18

ALBERTINI, Alberto, 1879-1954. Italian novelist and brother of
Luigi Albertini.
February 3, 1938 1

ALBERTINI, Luigi, 1871-1941. Italian journalist and former di-
rector, *Corriere della Sera.*
September 28, 1934 1

ALBERTSON, Hazel. Step-sister of Faye Albertson, former wife
of Walter Lippmann.
December 15, 1954-December 31, 1955 5

ALCOTT, Mary G. Mother of Lucy May Alcott Perkins.
To MB:
October 5, 1901 1

ALDRICH, Amey O., 1873-1963. Sister of Chester Holmes Aldrich.
November 9, 1939-April 20, 1949 17
No date 5
To MB:
January 18, 1940-June 2, 1941 3

ALDRICH, Chester Holmes, 1871-1940. American architect, head of the American Academy in Rome.
March 6, 1940-September 3, 1940 2

ALFASSA, P., 1876-1949. French art critic.
April 2, 1927 1

ALLASON, Barbara, b. 1877. Italian literary critic and biographer.
December 1957-December 8, 1958 4

ALLIATA CINI, Yana. Daughter of Count Vittorio Cini, wife of Prince Fabrizio Alliata di Salaparuta.
November 11, 1953-February 20, 1954 7

ALPATOV, Mikhail Vladimirovitch, b. 1902. Russian art historian.
October 10, 1925 1

ALTMAN, Benjamin, 1840-1913. American businessman, philanthropist, and art collector.
April 14, 1909-December 17, 1909 13

ALTROCCHI, Rudolph, 1882-1953. American professor of Italian literature.
September 20, 1929-November 4, 1929 2

ALVARO, Corrado, 1891-1956. Italian novelist.
No date 1

AMES, Edward Raymond. Boston acquaintance.
November 15, 1929-September 30, 1933 4

ANCONA, Duke Eugenio of, b. 1906. Son of Duke of Genova, member of Aosta branch of the Savoias.
October 17, 1944-June 20, 1946 7

ANDREWS, Cicily.
See: West, Rebecca.

ANDREWS, Henry Maxwell. English financier and economist, husband of Rebecca West.
December 31, 1952-November 25, 1956 18

ANET, Claude, 1868-1931. French art dealer.
April 7, 1916-September 29, 1916 3

ANNIGONI, Pietro, b. 1910. Italian painter.
April 26, 1956-August 4, 1959 4

ANREP, Baroness Alda, b. 1883. Librarian of I Tatti, 1929-1962, and sister of Nicky Mariano.
September 11, 1923-July 20, 1954 80

cont.

To MB:
July 5, 1928-July 24, 1940 38
See also: Salmi, Mario

ANTHEIL, George, 1900-1959. American composer.
November 26, 1956-May 1, 1958 3

ANTHONY, Edgar Waterman, 1890-1947. American art historian.
January 23, 1928-May 16, 1947 6

AOSTA, Duchess Anna of, b. 1906. Widow of Duke Amedeo of Aosta.
March 24, 1954-June 26, 1955 4

ARGYROPOULOS, Kaity Kyriazi. Wife of Dr. Alexander J. A. Ar-
gyropoulos, Greek diplomat.
April 24, 1955 1

ARKIN, Frances S. American psychoanalyst, cousin of Bernard Ber-
enson.
August 7, 1950-September 25, 1956 54

ARMSTRONG, Hamilton Fish, b. 1893. American editor of journal,
Foreign Affairs.
November 30, 1949 1

ASCOLI, Max, b. 1898. Italian-born writer and editor, publisher of
American journal, *The Reporter.*
September 5, 1931-February 26, 1957 12

ASHTON, Sir Leigh, b. 1897. English art historian and museum
director.
No date 1

ATLANTIS VERLAG, Zürich.
See: Hürlimann, Bettina
Hürlimann, Martin

AUBERT, Marcel, b. 1884. French archaeologist, art historian and
museum curator.
July 31, 1951 1

AURITI, G., b. 1883. Italian diplomat and art collector.
April 25, 1946-January 28, 1949 9

AVERARDI, F. Bruno. Italian writer.
December 12, 1930 1
No date 1

AYNARD, Edouard, 1837-1913. French politician and art collector.
April 15, 1906 1

BACCHELLI, Riccardo, b. 1891. Italian novelist and playwright.
January 30, 1937-February 25, 1956 7

BACHE, Jules Semon, 1861-1944. American financier and art collector.

August 10, 1927-June 14, 1935 37

To MB:
August 10, 1927-June 25, 1930 4

BADRUTT, Hans. Owner, Palace Hotel Badrutt, St. Moritz.
September 21, 1934-October 4, 1934 2

BAKER, Walter Cummings, b. 1893. American financier and art collector.
May 24, 1950-June 6, 1950 2

BAKST, Léon, 1866-1924. Russian painter and set designer.
May 29, 1916 1

To MB:
May 29, 1916 1

BALBO, Italo, 1896-1940. Governor of Tripolitania and Cirenaica, 1934-1940.
January 21, 1935-December 30, 1936 7

BALDERSTON, John Lloyd, 1889-1954. American journalist, playwright and screenwriter.
April 18, 1918-April 15, 1920 7

BALDWIN, Florence, 1859-1918. Mother of Gladys, Duchess of Marlborough and of Dorothy Palffy.
August 16, 1915 1
No date 3

To MB:
April 8, 1903-June 29, 1918 2

BALDWIN, Leland Dewitt, b. 1897. American historian.
October 7, 1945-December 4, 1958 23
No date 1

BALDWIN, Ruth Glosser. Wife of Leland Dewitt Baldwin.
No date 1

BARAČ, Josép. Yugoslav professor of literature.
1936 1

BARBANTINI, Nino, 1884-1952. Italian art connoisseur and writer.
January 1, 1946-March 24, 1952 6

BARBIERI, Enrico B. Italian writer.
November 6, 1955 1

BARLOW, Samuel Latham Mitchell, b. 1892. American composer
 and writer.
 June 1, 1949-July 14, 1958 7
 No date 10

 To Daniel Varney Thompson:
 April 1952 1

BARNEY, James W. American acquaintance.
 February 27, 1931 1

BARNEY, Natalie Clifford, b. 1877. American poet.
 April 15, 1917-December 31, 1955 34
 No date 17

BARR, Alfred Hamilton, Jr., b. 1902. American art historian, writer
 and museum director.
 September 15, 1949-March 5, 1951 3
 No date 1

BARR, Margaret Scolari. Italian-born American art historian, wife
 of Alfred Hamilton Barr, Jr.
 May 22, 1936-September 1, 1958 77
 No date 17

 To NM:
 November 27, 1958-February 15, 1959 2
 See also: Rockefeller, John Davison, Jr.

BARRY, John S. American military officer.
 No date 1

BASSIANO, Marguerite.
 See: Caetani, Marguerite

BATISTA Y SALVIDAR, Fulgencio, b. 1901. Head of Cuban gov-
 ernment, 1940-1944, 1952-1959.
 June 2, 1955 1

BAUSCH, Erika. German writer, born Baroness Hornstein.
 November 1, 1954 1

BAVARIA, Prince Henry of, 1922-1958. Son of Prince Rupprecht of
 Bavaria.
 No date 2

BAVARIA, Prince Rupprecht of, 1869-1955. Son of Prince-Regent
 Luitpold of Bavaria.
 April 2, 1945-January 5, 1953 13

BAYLEY, John Barrington, b. 1914. American architect.
 March 23, 1954-November 10, 1954 4

BAYNE, Edward Ashley, b. 1913. American economist and sociologist.
February 26, 1956-August 5, 1958 18

BAZIN, Germain. French art historian and museum curator.
June 2, 1951-November 15, 1956 4

To NM:
March 7, 1957-March 27, 1957 2

BEALE, Marie Truxton. Washington acquaintance, promoted and
helped restoration of Saint Mark's, Venice.
April 23, 1947-August 30, 1950 7
No date 2

BEATON, Cecil, b. 1904. English photographer and scenic and cos-
tume designer.
March 29, 1955-April 14, 1955 2

BECKER, Bernice A. Relative of Bernard Berenson.
September 9, 1957 1

BEDOYÈRE, Count Michael de la, b. 1900. Anglo-French writer,
editor of *Catholic Herald,* 1934-1962.
October 6, 1949-April 5, 1950 3

BEECHER, Henry Knowles, b. 1904. American surgeon and anaesthe-
tician.
May 1, 1946 1

BEHRMAN, Samuel Nathaniel, b. 1893. American playwright.
January 31, 1951-August 11, 1954 6
No date 1

BEIT, Sir Otto, 1865-1930. German-born English financier and phi-
lanthropist.
January 31, 1927 1

BELL, Charles Francis, b. 1871. English art historian and museum
curator.
February 16, 1913-June 10, 1951 81

To NM:
June 5, 1928-August 22, 1928 2

BELL, Hamilton. American art connoisseur.
August 9, 1921-April 8, 1925 5

To Daniel Varney Thompson:
July 22, 1936 1

BENEDETTO, Luigi Foscolo, b. 1886. Italian professor of French
literature.
April 16, 1934 1

BENN, Alfred William, 1843-1916. English philosopher.
January 24, 1909-December 22, 1909 3
No date 1

BENNETT-GOLDNEY, Frank. English acquaintance.
June 12, 1909-July 21, 1909 3

BENSON, Sir Rex Lindsay, b. 1889. English financier, son of Robert
Henry Benson.
April 26, 1945-January 18, 1946 5

BENSON, Robert Henry, 1850-1929. English financier and art col-
lector, father of Sir Rex Lindsay Benson.
April 4, 1894-August 9, 1928 25
No date 1

BENZONI, Giuliana, b. 1895. Daughter of Titina Martini Ruffino.
March 25, 1934-January 29, 1942 11

BERCOVICI, Leonardo. Rumanian-born American playwright.
December 12, 1952-January 21, 1954 2
No date 1

BERENSON, Abie, 1873-1936. Younger brother of Bernard Berenson.
February 25, 1901-June 24, 1935 29

To MB:
October 24, 1901-January 22, 1904 9

BERENSON, Albert, 1845-1930. Father of Bernard Berenson.
See: Part II a

BERENSON, Arthur, 1879-1944. American lawyer, cousin of Bernard
Berenson.
May 4, 1921-November 13, 1937 27
No date 2

BERENSON, Bernard, 1865-1959.
See: Part II a

BERENSON, Bessie.
See: Berenson, Elizabeth

BERENSON, Elizabeth, b. 1879. Sister of Bernard Berenson.
May 7, 1911-June 8, 1956 65
No date 20
See also: Perry, Ralph Barton

BERENSON, Julia, 1847-1938. Mother of Bernard Berenson.
To MB:
October 28, 1924 1
No date 1

BERENSON, Lawrence. American lawyer, cousin of Bernard Berenson.

February 12, 1921-January 25, 1959 476

To MB:
October 17, 1922-August 25, 1956 4

To NM:
May 13, 1940-1953 246

See also: Frankfurter, Felix
 Hofer, Philip
 Russell, Alys
 Welles, Sumner

BERENSON, Mary, 1864-1945.
See: Part II b

BERENSON, Rachel
See: Perry, Rachel Berenson

BERENSON, Richard Arthur, b. 1908. Cousin of Bernard Berenson.
December 16, 1954-June 6, 1956 4

BERENSON, Robert, 1914-1965. Aide de camp of General Mark Clark, 1943-1944, and cousin of Bernard Berenson.
May 17, 1946-January 8, 1959 6
No date 4

BERENSON, Senda.
See: Abbott, Senda Berenson

BERGENSTRÖM, Ernst. Swedish financier.
January 2, 1928 1

BERGMAN, Sidney M. American physician.
February 25, 1955-October 4, 1955 2

BERGSON, Henri Louis, 1859-1941. French philosopher.
June 25, 1912-November 16, 1914 2

BERLIN, Sir Isaiah, b. 1909. English philosopher and historian.
April 12, 1953-April 11, 1958 4

BERNARDI, Marziano. Italian art critic and journalist.
January 19, 1951 1

BERNSTEIN, Zoë. English acquaintance.
April 13, 1950-May 11, 1950 4

BERRY, Walter Van Rensselaer, 1857-1927. American lawyer.
April 21, 1910-October 30, 1926 37
No date 28

BERTAUX, Emile, 1869-1917. French archaeologist and art historian.
 May 6, 1909-November 20, 1909 2
 No date 1

BERUETE, Aurelino de. Spanish art historian.
 November 2, 1906 1

BETTINI, Sergio. Italian Byzantinist and art historian.
 December 31, 1942-May 26, 1948 9

BIANCHI BANDINELLI, Ranuccio, b. 1900. Italian archaeologist.
 June 26, 1941-September 15, 1951 19

BIBESCO, Princess Marthe, b. 1890. Franco-Rumanian writer.
 June 5, 1912-October 9, 1912 2

BIDDLE, Francis, b. 1886. American lawyer and U.S. Attorney General, 1941-1945.
 November 13, 1948 1

BIDDLE, George, b. 1885. American painter and sculptor.
 June 1, 1953-March 3, 1959 11

BIGELOW, William Sturgis, 1850-1926. American physician and orientalist.
 March 1, 1911 1

 To Ralph Curtis:
 November 15, 1918-May 29, 1919 3

BING, Gertrude, 1892-1964. German-born English art historian, Director, Warburg Institute, London.
 November 12, 1930 1

BINYON, Robert Laurence, 1869-1943. English poet, art historian and critic.
 January 7, 1915-January 4, 1939 20

 To MB:
 July 3, 1932-February 7, 1937 2
 No date 2

BIRNBAUM, Martin, b. 1878. Hungarian-born American art dealer and writer.
 August 21, 1953-August 29, 1957 9

BIRON VON CURLAND, Helene. German acquaintance.
 August 14, 1945 1
 No date 2

BIRRELL, Augustine, 1850-1933. English writer and statesman.
 October 24, 1927 1

BLAGDEN, William. English physician.
January 29, 1918 1

To MB:
June 7, 1922-December 22, 1922 2
No date 1

BLANCHE, Jacques Emile, 1861-1942. French painter.
April 21, 1913-December 22, 1930 2
No date 2

BLISS, Mildred, b. 1875. Donor of Dumbarton Oaks to Harvard
University, wife of Robert Woods Bliss.

To Ralph Curtis:
April 5, 1917 1

BLISS, Robert Woods, 1875-1962. American diplomat, donor of Dum-
barton Oaks to Harvard University.
June 1, 1937-February 3, 1958 18

To Wolfgang Friedrich Volbach:
March 27, 1946 1

BLOCHET, Edgar, 1870-1937. French orientalist, manuscript curator
at Bibliothèque Nationale, Paris.
December 12, 1930-December 30, 1935 16

BLYNAS, Zenonas. Lithuanian journalist.
April 21, 1936-November 15, 1936 3

BOAS, George, b. 1891. American professor of philosophy.
July 17, 1939-August 26, 1939 3

BÔCHER, Ferdinand, 1833-1928. French professor of literature.
March 1, 1894 1

BODMER, Martin. Swiss bibliophile and book collector.
November 4, 1948-December 1948 2
No date 1

BOEHLER AND STEINMEYER. Munich, Lucerne, and New York
art dealers.
August 30, 1910-June 15, 1953 94

BOËTHIUS, Carl Axel, b. 1889. Swedish archaeologist and former
director of Swedish Archaeological Institute, Rome.
February 28, 1926-August 15, 1959 125

BOHLEN, Avis Howard Thayer. Wife of Charles Eustis Bohlen,
American diplomat.
January 7, 1955-December 1956 8

BOMPIANI, Valentino. Director, Bompiani and Co., Milan publishers.
July 8, 1946-August 28, 1956 4

BONAFÉ, Félix. French writer.
June 21, 1956 1

BONDY, Oscar. Austrian art collector.
December 8, 1933 1

BONNARD, Abel, b. 1883. French poet and novelist.
May 20, 1918-January 27, 1940 9
No date 3
To MB:
August 15, 1921 1

BONNER, Paul Hyde, 1893-1964. American novelist.
November 15, 1952-December 29, 1958 31
No date 5

BOOTH, Ralph Harman, b. 1873. American businessman, publisher, editor and art collector.
October 25, 1922-June 14, 1937 5

BORCHARDT, M. L. Widow of Rudolph Borchardt, German poet, and niece of Rudolf Alexander Schroeder, German poet.
June 27, 1943 1

BORGESE, Leonardo. Italian journalist and art critic.
April 20, 1950-July 20, 1950 2

BORGHESE, Princess Alys. French-born Princess Caraman-Chimay.
July 15, 1932-December 29, 1934 3

BOSWORTH, William Welles, b. 1869. American architect.
February 21, 1930-September 29, 1953 9

BOTOND, Patricia. Wife of Istvan Botond, former wife of Henry Luce III.
September 1949-March 1954 24

BOTTENWIESER, Paul. German art dealer.
April 25, 1927-July 18, 1928 2

BOTTLEY, E. P. English art collector.
August 12, 1951-January 28, 1954 8

BOUCHOT-SAUPIQUE, Jacqueline, b. 1893. French art historian and museum curator.
January 1, 1952-November 6, 1957 4

BOURGET, Paul, 1852-1935. French novelist.
June 25, 1909-December 21, 1910 3

BOUVIER, Jacqueline.
 See: Kennedy, Jacqueline Lee Bouvier
BOUVIER, Lee.
 See: Radziwill, Princess Lee Bouvier
BOYLE, Mary E. English assistant to Abbé Breuil, archaeologist and
 paleontologist.
 Febuary 23, 1950 1
BRADBURY, Ray Douglas, b. 1920. American science-fiction writer.
 January 15, 1954-September 21, 1959 16
BRADLEY, Katherine.
 See: Field, Michael
BRANDI, Cesare, b. 1906. Italian art historian and writer.
 March 2, 1931 1
BRANDT, Ingeborg. German journalist.
 September 22, 1950-August 11, 1951 6
BRAUNFELS, Wolfgang, b. 1911. German art historian.
 April 30, 1951-January 11, 1957 3
BREASTED, James Henry, 1865-1935. American Egyptologist.
 November 2, 1935 1
BREITNER, Hugo. Austrian lawyer.
 April 3, 1938-November 29, 1938 6
BREWSTER, Elizabeth, 1878-1956. German painter.
 November 16, 1943 1
BRIDGE, Ursula St. Quintin. English writer.
 March 16, 1955 1
BRIDGES, Robert Seymour, 1844-1930. English poet.
 May 12, 1927 1
 No date 4
BROCKWELL, Maurice Walter, 1869-1958. English art connoisseur.
 June 15, 1909-July 15, 1935 4
 No date 1
BROMLEY-DAVENPORT, Lenette. American-born English art col-
 lector, wife of Lieut. Col. Sir Walter Henry Bromley-Davenport.
 January 10, 1953-April 6, 1954 3
 No date 3
BROOKS, Van Wyck, 1886-1964. American essayist and literary his-
 torian.
 January 29, 1952-October 8, 1958 21

BROSIO, Manlio, b. 1897. Italian lawyer and diplomat.
August 3, 1954-March 3, 1956 5

BROWN, John Carter, b. 1934. American art historian and museum
curator, son of John Nicholas Brown.
October 16, 1958-July 23, 1959 9

To NM:
October 16, 1958 1

BROWN, John Nicholas, b. 1900. American philanthropist and art
connoisseur.
January 7, 1929-November 7, 1958 5

BROWNELL, Kitty. Boston acquaintance.
July 7, 1934-May 12, 1955 12

BRUCE, Edward, 1879-1943. American painter and art collector.
November 23, 1938 1

BRUCE, Henry. English writer.
August 2, 1916-May 6, 1921 9

BRYN MAWR COLLEGE ALUMNAE ASSOCIATION.
See: Epes, Mrs. W. Perry

BUCKLER, William Hepburn, 1867-1952. English historian and ar-
chaeologist.
April 23, 1932-February 8, 1938 5

BULLITT, William Christian, b. 1891. American diplomat.
January 19, 1923 1

BUNDY, McGeorge, b. 1919. American political scientist and govern-
ment official.
April 20, 1956-October 16, 1958 12
No date 2

BUNKER, Ellsworth, b. 1894. American businessman and diplomat.
January 4, 1953 1
No date 1

BURCKHARDT, Carl J., b. 1891. Swiss historian and diplomat.
October 15, 1957-November 15, 1957 2

BURKE, Helene L. Widow of Bernard and Mary Berenson's English
friend Jack Burke.
December 1, 1936 1

To MB:
November 18, 1936 1

BURLINGHAM, Charles Culp, 1858-1959. American lawyer.
December 22, 1952-November 13, 1958 3

To Gaetano Salvemini:
December 4, 1952 1

BURNHAM, Marcia Lightner. Wife of James Burnham, American writer and editor of journal, *The National Review*.
June 27, 1950-November 5, 1950 2

BUSCHBECK, Ernst, 1889-1963. Austrian art historian and museum director.
April 18, 1938 1

BUXTON, John. English literary critic.
November 25, 1954-December 8, 1955 6

BYAM SHAW, John James, b. 1903. English art connoisseur and critic, director of Colnaghi and Co., Ltd., London art dealers, since 1937.
June 30, 1932-June 11, 1954 10

BYNNER, Hal Witter, b. 1881. American poet and playwright.
December 27, 1955-January 8, 1958 10

CAETANI, Marguerite, Duchess of Sermoneta, 1880-1963. Founder and editor of journals, *Commerce* and *Botteghe Oscure*. Wife of Duke Roffredo Caetani.
December 28, 1937-January 4, 1947 4
No date 5

CAETANI, Roffredo, Duke of Sermoneta, 1871-1962. Italian composer.
July 7, 1947 1
No date 2

CAGNOLA, Don Guido, 1862-1954. Italian art collector.
August 27, 1914-June 27, 1948 33
No date 3

To MB:
March 20, 1920-July 17, 1929 8
No date 2

CAILLOIS, Roger, b. 1913. French writer.
June 25, 1951 1

CAIN, Julien, b. 1887. French historian and librarian of Bibliothèque Nationale, Paris.
October 28, 1937-January 18, 1954 3

CALAMANDREI, Piero, 1889-1956. Italian lawyer, politician and writer.
March 8, 1945-June 28, 1956 8

CALOGERO, Guido, b. 1904. Italian philosopher.
August 14, 1957 1

CALZA, Raissa. Italian museum director and wife of Guido Calza, archaeologist.
February 9, 1953 1

CAMBÓ, Francisco. Spanish financier and art collector.
July 21, 1927-February 19, 1949 13

CAMBON, Jules, 1845-1935. French diplomat, member of French Academy.
January 13, 1919-April 15, 1921 4

CAMERON, Elizabeth, 1857-1944. Wife of James Donald Cameron, American senator and ex-secretary of war.
March 7, 1919-January 28, 1936 10
No date 1

To Ralph Curtis:
October 26, 1918 1

CAMILLE, Sister M. American Franciscan.
October 6, 1937-April 9, 1951 10

CAMPBELL, A. C. American lawyer.
February 16, 1954-June 26, 1958 4

CANFIELD, Cass, b. 1897. Head of Harper and Brothers, New York publishers.
February 1, 1938-February 19, 1947 10

CANNON, Henry White, 1850-1934. American businessman and art collector.
August 14, 1906-June 24, 1931 4

CAPUTO, Giacomo, b. 1901. Italian archaeologist.
July 1, 1953 1

CARBONARA, Pasquale. Italian architect.
October 14, 1935-November 2, 1939 3

CARLI, Enzo, b. 1910. Italian art historian and writer.
August 18, 1950 1

CARMICHAEL, Montgomery, 1857-1936. English diplomat and writer.
January 4, 1904-March 5, 1912 3

To Count Rosolino Orlando:
October 22, 1916 1

CARNEY, Admiral Robert Bostwick, b. 1895. Retired American naval officer.
July 2, 1952-June 22, 1953 3

CARPENTER, G. R. American acquaintance.
March 21, 1894-April 4, 1899 2

CARPENTER, Rhys, 1889-1960. American archaeologist.
June 30, 1939-January 10, 1956 10

To MB:
January 18, 1923-January 28, 1932 3

CARRINGTON, Fitzroy, 1869-1954. American museum curator.
September 22, 1931-February 26, 1935 6

CARRITT, David. English art connoisseur and dealer.
September 15, 1947-May 26, 1955 13

To NM:
October 7, 1951 1

CARTER, Morris, 1877-1965. American museum director.
January 21, 1937-April 26, 1948 2

CASSADÓ, Gaspar, b. 1897. Spanish-born violoncellist and composer.
1937-July 16, 1946 2

CASTELBARCO, Emanuele di. Son-in-law of Arturo Toscanini.
May 31, 1954 1

CASTELNUOVO-TEDESCO, Mario, b. 1895. Italian-born American composer.
July 6, 1939-January 28, 1951 8

CASTRO, Americo, b. 1885. Spanish historian.
October 17, 1955 1

CAVAZZA, Count Filippo, 1887-1952. Italian economist and agriculturist.
October 15, 1940-October 9, 1941 4

CAVIGLIA, Enrico, 1862-1945. Field Marshal, Italian Army.
December 30, 1926-February 2, 1927 2

CECCHI, Dario. Italian painter and writer, son of Emilio Cecchi.
September 1945-October 1945 2
No date 4

CECCHI, Emilio, b. 1884. Italian writer, literary critic and journalist.
April 15, 1912-July 27, 1958 56

To NM:
September 30, 1945-January 14, 1948 2

CECCHI, Leonetta Pieraccini. Painter and writer, wife of Emilio Cecchi.
July 18, 1930-January 24, 1950 4

17

CECCHINI, Giovanni.　Italian archivist.
October 15, 1946　　　　　　　　　　　　　　　1
To MB:
December 10, 1946　　　　　　　　　　　　　　1
CECIL of Chelwood, Viscount, 1864-1958.　English statesman.
August 23, 1918　　　　　　　　　　　　　　　1
CHAGALL, Marc, b. 1887.　Russian-born painter.
October 27, 1948-June 27, 1955　　　　　　　　4
CHAMBRUN, Countess Clara Longworth de.　American-born writer
and wife of French General Charles Aldebert Chambrun.
December 29, 1931-December 27, 1932　　　　　2
No date　　　　　　　　　　　　　　　　　　2
CHANG, Hsin-Hai.　Chinese writer.
March 20, 1958　　　　　　　　　　　　　　　1
CHANLER, Margaret (Daisy), 1862-1952.　American writer and wife
of Winthrop Chanler.
September 29, 1934-August 20, 1952　　　　　　44
CHAPMAN, John Jay, 1862-1933.　American essayist and poet.
August 11, 1903-November 9, 1917　　　　　　17
CHAPMAN AND HALL, Ltd., London.　English publishers.
See: McDougall, John M.
CHARVET, Jean Félix, b. 1912.　French diplomat.
No date　　　　　　　　　　　　　　　　　　1
CHASTEL, André Adrien, b. 1912.　French art historian.
July 12, 1948-November 4, 1955　　　　　　　2
CHATTERJI, N.　Indian writer.
July 20, 1957　　　　　　　　　　　　　　　　1
CHEN, Shih-Hsiang, b. 1912.　Chinese professor of Far Eastern liter-
ature.
February 8, 1951-April 7, 1958　　　　　　　7
CHESNEY, Kellow.　English journalist.
March 3, 1949-July 20, 1955　　　　　　　　2
CHIERICI, Gino, 1877-1961.　Italian architect and member of Fine
Arts Administration in Italy.
November 28, 1937　　　　　　　　　　　　　1
CHIGI, Count Guido, b. 1880.　Founder of Accademia Chigiana, Siena.
July 10, 1945-April 6, 1950　　　　　　　　　7

CHOLMONDELEY, Sybil, b. 1894. Sister of Sir Philip Sassoon, and wife of 5th Marquess of Cholmondeley.

1936-January 8, 1954 4

CHURCHILL, Winston, 1871-1947. American writer.

To MB:
No date 1

CIARANFI, Anna Maria. Italian museum director.

May 5, 1932-January 11, 1934 7

CICOGNA, Countess Anna Maria. Daughter of Count Giuseppe Volpi, Italian financier.

August 16, 1954-April 12, 1958 48

CINELLI, Delfino, 1889-1942. Italian writer.

No date 1

CINI, Countess Lyda Borelli. Wife of Count Vittorio Cini.

January 1952-August 1958 9

CINI, Count Vittorio, b. 1885. Italian financier and philanthropist.

August 18, 1939-May 10, 1958 13

CLAFLIN, William Henry, Jr., b. 1893. American financier.

July 6, 1939 1

CLAPP, Frederick Mortimer, b. 1879. American poet, art connoisseur and museum director.

November 10, 1909-February 4, 1959 22

To MB:
May 25, 1936 1

CLARENDON PRESS, The.

See: Norrington, Arthur Lionel Pugh

CLARK, Alan, b. 1928. English historian and son of Sir Kenneth Clark.

April 27, 1955-May 17, 1956 2

CLARK, Elizabeth (Jane). Wife of Sir Kenneth Clark.

June 21, 1929-April 18, 1957 14
No date 26

To MB:
1929 1

To NM:
August 1, 1934 1
No date 1

CLARK, Sir Kenneth, b. 1903. English art historian and museum
director.
May 20, 1928-January 1959 132

To MB:
1925-June 20, 1935 17
No date 1

CLARK, Mark W., b. 1896. U. S. Army General.
January 21, 1946-May 11, 1946 3

CLARKE, Sir Ashley, b. 1903. English diplomat.
February 28, 1955-August 20, 1955 3

CLEMEN, Paul, 1866-1947. German art historian.
May 22, 1928-April 19, 1947 11

CLERICI, Fabrizio, b. 1913. Italian architect, painter and set de-
signer.
March 27, 1946-June 4, 1958 3
No date 1

CLIFFORD, Henry. American museum curator.
No date 1

COCKERELL, Sir Sydney Carlyle, 1867-1963. English art collector,
writer and museum director.
July 23, 1908-August 1, 1955 39

COCTEAU, Jean, 1891-1964. French poet and playwright.
July 21, 1950-August 19, 1950 3

COHN, Alfred E., 1879-1957. American physician.
November 22, 1925-October 14, 1952 21

COHN, Arthur M. Anglo-Australian acquaintance.
August 15, 1932-March 2, 1950 6

COLACICCHI, Giovanni, b. 1900. Italian painter and director of
Academy of Fine Arts, Florence.
September 26, 1941-August 29, 1955 5

COLASANTI, Arduino, 1877-1935. Italian writer and Director Gen-
eral of Fine Arts in Italy, 1919-1928.
March 4, 1906-December 5, 1933 15

COLEFAX, Sir Arthur, 1866-1936. English lawyer and husband of
Sibyl Colefax.
September 24, 1932 1

COLEFAX, Michael. Son of Sir Arthur and Lady Colefax.
November 1, 1939-September 26, 1950 3

COLEFAX, Sibyl, 1872-1950. London hostess and wife of Sir Arthur
 Colefax.

November 19, 1918-September 21, 1950 54
No date 341

To Beryl de Zoete:
No date 1

See also: Trevelyan, Robert Calverley

COLETTI, Luigi, 1886-1961. Italian writer, art historian and mu-
 seum director.

July 31, 1947 1

COLETTI, Umberto. Italo-American acquaintance.

April 16, 1947-October 24, 1948 4

COLLINS SONS AND CO., Ltd., William. London publishers.
 See: Waldman, Milton

COLLINS-STROUSE, Patricia. American secretary of Elsie de Wolfe.

January 11, 1953-December 8, 1954 6

COLVILLE, Norman, b. 1893. English art collector.

June 4, 1936 1

COMFORT, Howard. American diplomat.

August 27, 1951-September 10, 1951 2

CONANT, James Bryant, b. 1893. American scientist, educator and
 diplomat, President of Harvard University, 1933-1953.

November 14, 1933-January 12, 1934 2

CONKLIN, Edwin G., 1863-1952. American biologist.

May 19, 1950 1

CONNOLLY, Cyril Vernon, b. 1903. English literary critic, journal-
 ist and novelist.

June 18, 1946-February 19, 1953 6
No date 3

CONSTABLE AND CO., Ltd. English publishers.

January 11, 1946-August 2, 1949 35

CONSTABLE, William George, b. 1887. English museum director
 and writer.

May 31, 1927-July 10, 1958 144

To MB:
March 11, 1929-April 29, 1931 2

To NM:
July 21, 1932-October 11, 1957 2

cont.

3.

To Daniel Varney Thompson:
August 6, 1936 1

See also: Venier, Ottaviano

CONTINI BONACOSSI, Count Alessandro, d. 1957. Italian art collector and dealer.
December 27, 1939-May 7, 1950 4

CONWAY, William Martin, Baron Conway of Allington, 1856-1937.
English art critic and collector.
June 23, 1913-December 1, 1933 7

COOK, Mary (Marnie). Wife of Sir Herbert Frederick Cook, English art collector.
April 2, 1907 1

COOK, Walter William Spencer, 1888-1963. American art historian.
October 20, 1924-February 16, 1958 11

COOLIDGE, John, b. 1913. American museum director.
January 31, 1949-August 4, 1959 37
No date 2

To NM:
November 17, 1950-1959 2

See also: Yashiro, Yukio

COOPER, Alfred Duff, Viscount Norwich of Aldrich, 1890-1952. English writer and diplomat.
January 28, 1948-June 14, 1952 4
No date 1

COOPER, Edith.
See: Field, Michael

CORA, Giuliano, b. 1885. Italian diplomat.
June 7, 1931 1

CORTISSOZ, Royal, 1859-1943. American journalist and art critic.
August 5, 1924-March 27, 1943 39

To Edith Wharton:
February 7, 1930 1

CORY, Daniel. Literary executor of George Santayana.
January 21, 1954-January 30, 1954 2

COSSÉ-BRISSAC, Countess Charlotte de. One of Bernard Berenson's closest French friends.
February 4, 1909-October 8, 1952 94
No date 11

To MB:
October 12, 1908-April 2, 1927 2

COSSIO, Manuel B. Spanish educator and writer.
April 2, 1927 1

COSSIO DE JIMÉNEZ, Natalie. Daughter of Manuel B. Cossio.
July 28, 1950 1

To NM:
July 29, 1950-December 10, 1950 2

COSTER, Byba Giuliani. Italian-born wife of Charles Henry Coster.
August 15, 1930-October 8, 1951 7
No date 3

COSTER, Charles Henry, b. 1897. American scholar and historian.
August 15, 1928-August 29, 1959 76

To MB:
April 15, 1935-January 13, 1937 6

COUDENHOVE-KALERGI, Richard Nicolaus, b. 1894. Austrian
essayist and president of Paneuropean Union.
August 9, 1954 1

COX, Allyn, b. 1896. American painter.
June 9, 1930-May 8, 1954 3

CRAM, Ralph Adams, 1863-1942. American architect.
May 7, 1937-July 10, 1941 8

CRANE, Josephine B. American acquaintance.
October 30, 1930-December 9, 1930 2

CRAVERI-CROCE, Elena. Eldest daughter of Benedetto Croce, wife
of Raimondo Craveri.
No date 2

CRAVERI-GIACOSA, Paola. Mother-in-law of Elena Craveri-Croce.
February 7, 1949-March 1, 1949 2

CRAWFORD AND BALCARRES, David Robert Alexander Lindsay,
Earl of, b. 1900. Trustee of British Museum and National
Gallery, London.
March 31, 1940-September 1, 1958 20

CRAWFORD, Mary. Wife of David Robert Alexander Lindsay,
Earl of Crawford and Balcarres.
January 29, 1957 1

CRAWSHAY, Mary, 1858-1936. Daughter of Sir John Leslie and
wife of Robert Thomson Crawshay.
1904-January 8, 1930 56
No date 42

CRESWELL, Keppel Archibald Cameron, b. 1879. English architect
and art historian.

May 12, 1922-February 6, 1958 18

To MB:
August 17, 1922-July 4, 1932 5

CROCE, Benedetto, 1866-1952. Italian philosopher and historian.

1926-1952 11

To NM:
No date 1

CRONIN, Grover Jeremiah, Jr., b. 1914. American professor of Eng-
lish literature and editor of journal, *Liturgical Arts.*

April 4, 1950 1

CROWNINSHIELD, Francis (Frank), b. 1872. American journalist,
editor of journal, *Vanity Fair.*

January 2, 1914 1

CRUTTWELL, Maud. English art historian and writer.

To MB:
January 1900 1
No date 4

CUNARD, Victor, 1898-1962. English journalist.

December 14, 1953 1

CUNNINGHAM, Charles C., b. 1910. American museum director.

January 5, 1950-March 31, 1958 7

CUOGHI, G. B., d. 1944. Italian military officer.

January 1, 1941 1

CURTIS, Lisa, 1871-1933. Wife of Ralph Curtis.

December 6, 1917-March 21, 1918 2
No date 2

CURTIS, Ralph, 1854-1922. American painter and art collector.

January 6, 1909-June 10, 1922 386

See also: Bigelow, William Sturgis
 Bliss, Mildred
 Cameron, Elizabeth
 Gardner, Isabella Stewart
 Wendell, Barrett

CURTIUS, Ludwig, 1874-1954. German archaeologist.

May 16, 1936-September 29, 1937 3

CUST, Henry John Cockayne, 1861-1913. English politician and journalist.

February 15, 1910-November 3, 1913 2
No date 2

CUST, Robert Hobart. English art historian.

April 27, 1903-July 10, 1935 3
No date 9

To MB:
No date 12

CUTTING, Lady Sybil.
See: Lubbock, Lady Sybil

D'ABERNON, Viscount, formerly Sir Edgar Vincent, 1857-1941. English financier and diplomat.

October 11, 1927-October 25, 1927 2

D'ABERNON, Lady Helen, 1866-1954. Born Lady Helen Duncombe, wife of Viscount D'Abernon.

August 15, 1909-December 31, 1953 4

D'AJETA, Count Vasco. Italian diplomat.

March 10, 1947-March 26, 1947 2

DALLOLIO, Elsa, 1890-1965. Daughter of Italian general Dallolio.

December 1934-January 26, 1939 8

DAMERINI, Gino, b. 1884. Italian art critic, journalist and historian.

December 9, 1953 1

DAMON, Theron. Brother-in-law of George Herbert Huntington.

August 17, 1937-December 31, 1953 5

To MB:
June 23, 1929 1

DANIEL, Sir Augustus Moore, 1866-1950. English painter, art connoisseur and museum director.

October 4, 1932-September 20, 1933 7

D'ANNUNZIO, Gabriele, 1863-1938. Italian poet and novelist.

Easter 1908-July 3, 1912 2
No date 4

DARVALL, Frank Ongley, b. 1906. English writer and journalist.

August 22, 1958 1

To Adlai Ewing Stevenson:
August 22, 1958 1

DAVIES, Martin, b. 1908. English art critic, historian and museum curator.

March 27, 1947-February 13, 1952 12

To NM:
June 11, 1946 1

DAVIS, Fitzroy K. English art connoisseur.
No date 1

DAVIS, Theodore M., 1838-1915. American financier and art collector.
April 18, 1894 1

DAVISON, Robert. English acquaintance.
May 1, 1952 1

DAY-LEWIS, Cecil, b. 1904. English poet.
No date 1

DEACON, Gladys.
See: Marlborough, Gladys Deacon, Duchess of

DE ANGELIS D'OSSAT, Guglielmo, b. 1907. Italian architect and Director General of Fine Arts in Italy, 1946-1960.
January 30, 1948-December 29, 1949 2

DE BENEDETTI, Giacomo, b. 1901. Italian writer.
December 31, 1935 1

DE CHIRICO, Andrea.
See: Savinio, Alberto

DEGENHART, Bernhard, b. 1907. German art critic and historian.
October 31, 1945-February 8, 1954 4

To NM:
February 3, 1946-November 14, 1950 2

DE GRADA, Raffaele, b. 1916. Italian journalist.
June 19, 1957 1

DE KOVEN, Anna, 1862-1953. American writer and wife of Reginald de Koven, composer.
January 28, 1915-February 27, 1934 18
No date 9

DE LAMAR, Alice. American acquaintance.
May 23, 1946-August 24, 1951 2
No date 18

DELBRUECK, Richard, 1874-1957. German art historian.
July 2, 1956 1

DE LIBERO, Libero, b. 1905. Italian poet.
July 20, 1949-June 18, 1958 4

DELLA PERGOLA, Paola. Italian museum director.
July 10, 1954-July 17, 1954 2

DELLA SETA, Alessandro, 1879-1944. Italian archaeologist.
June 28, 1959-July 16, 1959 2

DELLA SETA, Maria Teresa. Wife of Alessandro Della Seta.
June 12, 1948 1

DEMANDOLX DEDONS, Count of. French art collector.
November 6, 1925-April 24, 1947 4

DE MARINIS, Tammaro, b. 1878. Italian bibliographer and book
collector.
December 31, 1952 1

To NM:
March 31, 1952 1

DE NICOLA, G., 1879-1926. Italian art critic, historian and museum
director.
February 14, 1918-December 31, 1925 20

D'ENTRÈVES, Alessandro Passerin, b. 1902. Italian professor of
philosophy of law.
December 14, 1935-March 19, 1953 25

DENVIR, Bernard. American journalist and art historian.
October 9, 1956 1

DE RICCI, Seymour, 1881-1942. English-born French bibliographer,
writer and lecturer.
January 8, 1924-December 12, 1935 7

DE RINALDIS, Aldo, 1881-1948. Italian art critic, historian and
museum director.
January 2, 1927-August 6, 1947 6

DE RINALDIS, Lina Sforza. Widow of Aldo De Rinaldis.
August 2, 1948-January 9, 1951 2

DE ROBECK, Nesta. English writer.
December 29, 1935-October 18, 1945 20

DE VITO BATTAGLIA, Silvia. Italian art critic and historian.
June 29, 1934-November 7, 1956 21

DE WALD, Ernest Theodore, b. 1891. American art historian.
December 18, 1944-January 7, 1947 2

DE WOLFE, Elsie, d. 1950. American interior decorator, wife of
Sir Charles Mendl.
1904-March 7, 1926 2

DE ZOETE, Beryl.
See: Zoete, Beryl de

DIANO, Carlo, b. 1902. Italian classical philologist.
January 31, 1952 1

DI CESARÒ, Duke Giovanni Colonna, 1878-1940. Italian politician,
prominent anti-Fascist.
January 9, 1940 1

DICKINSON, Goldsworthy Lowes, 1862-1932. English humanist,
historian and philosopher.
March 27, 1933 1

DIENEMANN, Mally, 1882-1963. Wife of Max Dienemann, Chief
Rabbi of Offenbach, Germany.
1949-1958 98

DIVONNE, Philomène de la Foret.
See: Sylve, Claude

DIXON, Sir Pierson, 1904-1965. English diplomat.
October 10, 1947 1

DOBBYN, R. Irish professor of Classics.
August 31, 1935-October 7, 1936 4

DODGSON, Campbell, 1867-1948. English art critic and historian.
May 8, 1904-March 9, 1926 3

DOHRN, Reinhard, b. 1880. German zoologist and son of Anton
Dohrn, creator of Naples Aquarium.
March 4, 1957-March 26, 1957 2

DONINI, Filippo. Italian writer, director of Italian Institute, Lon-
don.

To NM:
November 26, 1957 1

DORIA, Gino, b. 1890. Italian writer and historian.
February 10, 1951 1

D'ORSAY, Francesca, 1873-1938. Italian-born French novelist.
January 18, 1927-December 2, 1936 6
No date 1

DOUGLAS-WEST, Hilda. Secretary to Elsie de Wolfe.
July 4, 1950-August 27, 1957 20

DRAPER, Ruth, 1889-1956. American actress.
 September 20, 1946-June 27, 1955 4
 No date 13

DRIGO, Paola, 1876-1938. Italian novelist.
 June 2, 1935-December 27, 1937 68
 To MB:
 February 1, 1937 1

DU BOS, Charles, 1882-1939. Anglo-French writer.
 December 23, 1909-April 1, 1936 27

DU BOS, Zezette. Widow of Charles Du Bos.
 November 19, 1929-December 27, 1952 41
 No date 9
 To NM:
 October 16, 1951-December 8, 1953 3
 No date 2

DUBSKY, Adolf. Austrian diplomat.
 January 22, 1935-July 10, 1950 3
 No date 1

DUMBA DE LIEVEN, Aeni. Widow of Austrian diplomat.
 October 9, 1939-June 7, 1943 66

DUNHAM, Katherine. American choreographer, dancer and writer.
 May 9, 1945-August 14, 1958 73

DUNN, Gano, 1870-1953. American electrical engineer.
 March 29, 1924 1

DUNN, James Clement, b. 1890. American diplomat.
 February 4, 1947-October 31, 1957 5

DUVEEN BROTHERS. London, Paris and New York art dealers.
 December 18, 1906-April 16, 1940 1553
 To MB:
 August 14, 1907-August 25, 1937 136
 To NM:
 August 29, 1929-October 18, 1937 14

DVOŘÁK, Max, 1874-1921. Austrian art historian.
 February 4, 1920 1

EASTLAKE, Elizabeth, d. 1911. Wife of Charles Locke Eastlake, English art historian and museum director.
 June 19, 1893 1
 To MB:
 September 22, 1892-February 2, 1893 2

EASTMAN, Max, b. 1883. American writer and poet.
August 1, 1933-December 13, 1958 9

To NM:
May 23, 1959 1

EDE, H. S. (Jim). English art connoisseur and writer.
November 11, 1927 1

EDGELL, George Harold, 1887-1954. American art historian and
museum director.
November 28, 1922-April 13, 1954 43
See also: Perry, Ralph Barton

EINSTEIN, Carl. French director of art journal, *Documents*.
February 25, 1930-April 18, 1930 2

EISLER, Robert, b. 1882. Austrian historian and philosopher.
September 23, 1904-July 24, 1948 7
No date 2

To MB:
February 12, 1908 1

EISSLER, Hermann. Austrian art collector.
December 6, 1927 1

ELEY, Sir Geoffrey Cecil Ryves, b. 1904. English financier and
economist.
July 15, 1952-December 11, 1952 2

ELEY, Penelope. Wife of Sir Geoffrey Cecil Ryves Eley.
March 24, 1952-April 12, 1953 5
No date 1

ELGOOD, Bonté, 1874-1960. English physician and widow of Lieut.
Col. Percival Elgood.
January 30, 1951-October 26, 1957 10

ELLIS, Elizabeth. Sister-in-law of John Garrett, American diplomat.
To MB:
March 16, 1909 1

EMMOTT, Charles. English writer.
June 6, 1948 1

EPES, Mrs. W. Perry. Editor, Bryn Mawr College Alumnae Asso-
ciation, Bryn Mawr, Pennsylvania.
April 23, 1959 1

To NM:
May 13, 1959-September 8, 1959 2

EPSTEIN, Jacob, 1864-1947. American businessman, philanthropist
and art collector.
December 10, 1925-July 3, 1931 5

EPSTEIN, Leola. Widow of Max Epstein.
September 8, 1954 1

EPSTEIN, Max, 1875-1954. American financier and art collector.
May 28, 1928-September 20, 1934 12

ERICKSON, Alfred William, 1876-1936. American art collector.
August 8, 1927-September 7, 1927 2

ESCHMANN, Ernst Wilhelm. German writer.
November 9, 1949-December 31, 1956 7

ESKOLSKY, M. Israeli writer.
June 15, 1952 1

ETTINGHAUSEN, Richard, b. 1906. German-born American orien-
talist and museum curator.
January 10, 1955-August 19, 1957 5

EUMORFOPOULOS, George, 1863-1939. Anglo-Greek financier and
art collector.
October 15, 1936 1

EUSTON, Hugh Denis Charles Fitzroy, Earl of, b. 1919. English
museum trustee.
May 18, 1938 1

EYGES, Leon R. American lawyer and distant relative of Ber-
nard Berenson.
June 11, 1951-March 15, 1957 2

FABRE-LUCE, Alfred, b. 1899. French journalist and writer.
No date 1

FAIRFAX, Eve. English acquaintance.
March 15, 1949-October 28, 1949 4

FAISON, Samson Lane, Jr., b. 1907. American art historian and
educator.
April 7, 1938 1

FALCK, Maly da Zara. Wife of Giovanni Falck, Milanese in-
dustrialist and art collector.
May 30, 1943 1

FAUCHER-MAGNAN, Adrien, b. 1895. French writer and art
collector.
December 28, 1946 1

FEDI, Giuseppe. Italian Jesuit missionary.
July 6, 1956 1

FELICIANGELI, Bernardino. Italian historian.
December 7, 1905-November 7, 1907 4

FERMOR, Patrick Michael Leigh, b. 1915. English writer.
March 23, 1954-September 9, 1954 2

FERON-STOCLET, Raymonde. Daughter of Adolphe Stoclet, Bel-
gian art collector.
October 30, 1956 1

FERRANDO, Guido. Italian writer and philosopher.
July 1945 1

FERRI, Pasquale Nerino. Italian museum curator.
August 8, 1904-September 15, 1904 3

FERRIER, Kathleen, 1912-1953. English singer.
January 14, 1953 1

FIELD, Michael. Pen name of Katherine Bradley, 1846-1914, and
Edith Cooper, 1862-1913, English poets, aunt and niece respec-
tively.
1892-May 25, 1914 333

FIELDEN, Lionel, b. 1896. English writer.
April 20, 1945-February 22, 1955 12
To NM:
December 26, 1939 1
See also: Waglé, Premila

FILIPPINI, Francesco. Italian art historian.
October 10, 1916 1

FINCH, Edith, b. 1900. American writer and educator, fourth wife
of Bertrand Russell.
February 25, 1948 1

FINLEY, David Edward, b. 1890. American museum director.
September 3, 1938-July 16, 1959 15

FIOCCO, Giuseppe, b. 1884. Italian art historian.
July 11, 1939-January 1, 1951 3

FISCHEL, Oskar, 1870-1939. German art historian.
May 16, 1921-April 23, 1939 9

FISH, Hamilton, b. 1888. American politician.
No date 1

FISHER, Herbert Albert Lawrence, 1865-1940. English historian and statesman, Warden of New College, Oxford.
March 17, 1894 1

FLETCHER, Agnes H. Daughter of Jefferson Butler Fletcher.
March 15, 1947 1
To MB:
1911 2

FLETCHER, Jefferson Butler, 1865-1946. American poet and professor of literature.
August 10, 1930-September 8, 1945 6

FLEXNER, Abraham, 1866-1959. American educator.
June 30, 1954 1
To James Grover McDonald:
October 29, 1938 1

FLEXNER, Helen. Cousin of Mary Berenson and wife of Simon Flexner, American pathologist.
August 31, 1946 1

FLEXNER, James Thomas, b. 1908. American writer.
November 7, 1938-October 5, 1954 8

FOCILLON, Henri Joseph, 1881-1943. French art historian.
December 28, 1936-January 1, 1938 2
To MB:
December 28, 1936 1

FOCILLON, Marguerite. Wife of Henri Joseph Focillon.
March 1, 1938-November 20, 1948 5

FOLCH Y TORRES, Joaquin. Spanish art historian and museum director.
November 18, 1948-January 20, 1949 2

FORBES, Edward Waldo, b. 1873. American art historian and museum director.
May 14, 1915-October 10, 1958 113
See also: Perry, Ralph Barton

FORBES, Margaret. Wife of Edward Waldo Forbes.
To Daniel Varney Thompson:
January 5, 1963 1
See also: Thompson, Daniel Varney

FORESTI, Carlo. Italian art dealer and collector.
October 16, 1926-March 1, 1935 6
To NM:
May 29, 1927-June 2, 1927 2

FORSTER, Edward Morgan, b. 1879. English novelist.
February 12, 1933-May 6, 1952 2

FORTUNY Y DE MADRAZO, Mariano, 1871-1949. Spanish-French painter.
December 28, 1945 1

FOSSI, Marchese Piero, b. 1898. Italian writer and politician.
November 5, 1946-December 16, 1956 9

FOUCHER, Alfred, b. 1865. French archaeologist.
July 29, 1929 1

FOURNEAU, J. Claude. French painter.
March 6, 1941-August 5, 1941 2

FOWLE, James Warren, b. 1920. American art historian.
May 7, 1949-July 21, 1949 2

FOWLE, Luther Richardson, b. 1886. Treasurer, American Board of Missions.
August 25, 1949-October 6, 1949 2

FOWLES, Edward, b. 1885. Member of Duveen Brothers.
March 7, 1940-December 18, 1957 69

FRANCHETTI, Dorothy. Daughter-in-law of Baroness Marion Franchetti.
July 7, 1945 1

FRANCHETTI, Baroness Marion, 1870-1948. German-born widow of Baron Giorgio Franchetti, Italian art collector.
October 11, 1942-June 4, 1947 2

FRANCIS, Henry Sayles, b. 1902. American art historian and museum curator.
December 17, 1937-September 6, 1958 51
No date 1

FRANCIS, Henry Sayles, Jr. Geologist and explorer, son of Henry Sayles Francis.
February 12, 1953-October 3, 1958 6
No date 1

FRANCOVICH, Géza de, b. 1902. Italian art historian.
November 10, 1945-January 12, 1950 2

FRANKFURTER, Alfred M., d. 1965. American journalist and art connoisseur.
July 19, 1933-June 21, 1952 13

FRANKFURTER, Eleanor. Daughter of Thomas Munro and wife of Alfred M. Frankfurter.
July 19, 1958 1

FRANKFURTER, Felix, 1882-1965. U. S. Supreme Court Justice.
March 14, 1918-November 29, 1946 10

To Lawrence Berenson:
April 27, 1949 1

To Count Carlo Sforza:
November 14, 1945 1

FREEDBERG, Sydney Joseph, b. 1914. American art historian.
February 22, 1948-August 21, 1959. 7
No date 3

FREEDMAN, Anna G. American physician and cousin of Bernard
Berenson.
April 21, 1950-July 20, 1957 42

FREEDMAN, Louis A. Cousin of Bernard Berenson.
July 29, 1935-May 14, 1956 36

FREEDMAN, Louis M. American physician and cousin of Bernard
Berenson.
July 23, 1958 1

FREER, Charles Lang, 1856-1919. American art collector and founder
of Freer Gallery of Art, Washington, D. C.
June 12, 1914-May 10, 1918 6

FREMANTLE, Anne. English-born American writer.
October 2, 1951-March 8, 1954 3
No date 1

FRICK, Helen C. Founder of Frick Art Reference Library, New
York.
January 25, 1950-August 6, 1958 15

To NM:
January 6, 1959 1

FRIEDBERG, Judith. American journalist and cousin of Bernard
Berenson.
May 26, 1952-April 7, 1958 9

To NM:
July 15, 1959 1

FRIEDBERG, Louis. Relative of Bernard Berenson.
February 16, 1900 1

FRIEDLÄNDER, Max J., 1867-1958. German art historian and
museum director.
June 5, 1925-July 8, 1955 21

FRIEDSAM, Michael, 1858-1931. American financier and art collector.
November 24, 1923-February 20, 1925 2

FRIZZONI, Gustavo, 1840-1919. Italian art critic and collector.
April 2, 1894-June 17, 1916 23

FROEHNER, Wilhelm, 1835-1925. French archaeologist and museum curator.
June 27, 1924-March 6, 1925 7

FRÖHLICH BUME, Lili. Austrian-born English art historian.
December 16, 1951-January 10, 1952 2

FRY, Roger, 1866-1934. English painter and art critic.
December 2, 1900-April 21, 1916 11
To MB:
January 23, 1902-February 6, 1932 28

GAETANI, Count Alfonso, b. 1903. Former prefect of Florence, president of Confederation of Italian Agriculturists.
January 1, 1945 1

GAFENCU, Grigoire, 1892-1957. Rumanian statesman and writer.
June 7, 1946 1

GALBIATI, Monsignor Giovanni. Italian librarian, former prefect of Biblioteca Ambrosiana, Milan.
November 17, 1948 1

GALLARATI-SCOTTI, Duke Tommaso Fulco, b. 1878. Italian literary critic, novelist and diplomat.
March 14, 1954 1

GALLUP, Donald Clifford, b. 1913. American educator and bibliographer.
July 23, 1952-August 1, 1952 2

GAMBA, Count Carlo, 1870-1963. Italian art historian and connoisseur.
June 21, 1903-March 16, 1959 21
No date 1
To NM:
August 18, 1955 1

GANTNER, Joseph, b. 1896. Swiss art historian.
April 23, 1948-May 13, 1948 2

GARDNER, Burdett Harmon, b. 1917. American writer and teacher.
August 19, 1951-July 5, 1952 4

GARDNER, Isabella Stewart, 1840-1924. Founder of Isabella Stewart Gardner Museum, Boston.

March 15, 1894-June 11, 1924	305
No date	2

To Ralph Curtis:
May 28, 1921	1

To Barrett Wendell:
May 1918	1

GARDNER, Rose. Wife of George Peabody Gardner, American financier.

December 28, 1955	1

GARGIULO, Alfredo, 1876-1949. Italian literary critic.

June 16, 1948	1

GARRISON, Lloyd Kirkham, b. 1897. American lawyer.

April 5, 1937-March 28, 1950.	4

GASPARIN, Edith de. Friend of Houston Stewart Chamberlain and member of the Wagner circle in Bayreuth.

December 27, 1928-October 7, 1958	205

GATES, Elizabeth. Cousin of Bernard Berenson.

November 2, 1953-May 21, 1958	22

GATES, Helen.

See: Huntington, Helen

GATES, William. American lawyer and husband of Elizabeth Berenson Gates, cousin of Bernard Berenson.

November 1, 1953-November 12, 1955	4

GATHORNE-HARDY, Robert, b. 1902. English writer.

June 10, 1946-August 16, 1954	14

GEARING, Frank H. English art amateur.

June 5, 1930-May 11, 1931	5

GELLHORN, Martha. American writer and journalist, former wife of Ernest Hemingway, remarried to T. S. Matthews.

April 2, 1950-January 8, 1959	29
No date	43

To NM:
No date	1

GERTZ, Elmer. American biographer.

September 23, 1929	1

GEST, Simeon. Cousin of Bernard Berenson and brother of Maurice Gest, theatrical producer.

July 27, 1956	1

4.

GETTY, Jean Paul, b. 1892. American financier, art collector and founder of J. Paul Getty Museum, Malibu, California.
October 2, 1952-November 15, 1957 29

GIANUIZZI, Giovanni. Grandson of Pietro Gianuizzi, Italian art historian.
1954 1

GILBERT, Creighton, b. 1924. American art historian.
January 31, 1951-February 9, 1956 9

GILBERT, Katharine. American philosopher and psychologist, mother of Creighton Gilbert.
December 20, 1947-May 8, 1951 7

GILES, Frank. English journalist, editor of *The Sunday Times*.
February 7, 1951-August 10, 1958 14

GILLET, Louis, 1876-1943. French art historian and member of French Academy.
January 1, 1903-June 18, 1943 181

GILLET, Suzanne. Widow of Louis Gillet.
June 21, 1943-October 31, 1946 6

GIMPEL, René. French art dealer.
February 3, 1920-January 15, 1930 27
No date 4

GLAENZER, Eugene. English art dealer.
December 24, 1903-January 17, 1912 54
No date 11

To MB:
March 11, 1904-December 30, 1905 4

GLÜCK, Gustav, 1871-1952. Austrian art historian and museum director.
January 10, 1926-October 4, 1926 4

GNECCHI, Alberto. Italian writer.
February 21, 1943-September 3, 1944 2

GNOLI, Umberto, 1879-1947. Art historian and member of Italian Fine Arts Administration.
March 1, 1910-June 3, 1945 26

GODFREY, Frederick M. English art historian.
August 15, 1952-August 24, 1952 2

GODWIN, Blake-More, b. 1894. American museum director.
July 17, 1950-November 15, 1951 4

GOLDMAN, Henry, 1856-1937. American art collector.
February 13, 1924 1

GOLDMAN, Julia. Cousin of Bernard Berenson.
December 14, 1948-December 5, 1951 8

GOLDMAN, William. Cousin of Bernard Berenson.
No date 1

GOLDSCHMIDT, Adolph, 1863-1944. German art historian.
May 5, 1934-January 26, 1943 4

GOLDSMITH, Bertram S. American financier.
November 13, 1945-February 16, 1950 8

GOLOUBEV, Victor. Russian-born French archaeologist.
February 6, 1915-June 12, 1924 8

GOSCHEN, Vivienne.
See: Watteville, Vivienne de

GOULD, Cecil Hilton Monk, b. 1918. English art historian and museum curator.
August 18, 1952-November 16, 1953 2

GOWING, Lawrence Burnett, b. 1918. English painter and art historian.
July 2, 1949-October 2, 1949 2

GRANDI, Carlo. Italian art dealer and collector.
September 18, 1906 1

GRANVILLE-BARKER, Harley, 1877-1946. English actor, producer, dramatist and critic.
February 13, 1937-February 22, 1937 2

GRANVILLE-BARKER, Helen.
See: Huntington, Helen

GRASSI, Ernesto. Italo-German writer and philosopher.
December 30, 1943-April 2, 1952 7

GRAVINA, Countess Maria Sofia Giustiniani Bandini. Widow of Count Manfredi Gravina, Italian diplomat.
December 7, 1934-December 21, 1941 4

GRAZIOLI, Duchess Nicoletta. Born Princess Giustiniani Bandini.
No date 1

GREEN, Andrew. American planter in the West Indies.
To MB:
October 20, 1926-December 18, 1936 3

GREENE, Belle da Costa, 1877-1950. Librarian of Pierpont Morgan
Library, New York.
February 23, 1909-December 21, 1948 615

To Daniel Varney Thompson:
September 10, 1945 1

GREENLEES, Ian Gordon, b. 1913. English writer and director of
British Institute, Florence.
February 17, 1949 1

GREENSLET, Ferris, 1875-1959. American publisher and writer.
April 2, 1947-September 20, 1957 32

GREFFULHE, Countess Marie-Anatole-Louise-Élisabeth, b. 1860.
Born Princess de Caraman-Chimay.
July 2, 1909-August 30, 1915 2

GREG, Julia Schreiner, d. 1953. American-born wife of Sir Robert
Hyde Greg.
To MB:
July 14, 1923-August 22, 1924 5

GREG, Sir Robert Hyde, 1876-1953. English diplomat.
February 21, 1922-November 22, 1953 70

To MB:
April 18, 1925 1

GREGORIETTI, Guido. Italian art historian and museum curator.
To NM:
August 29, 1956-November 11, 1957 9

GREGORY, Harold Anthony. American art student.
June 28, 1955 1

GREGORY, Virginia. French professor of literature.
August 8, 1946-April 19, 1957 65

GREIG, Charles Alexis, 1880-1958. English diplomat.
June 3, 1938 1

GRENIER, Baroness Giovannella Caetani. Sister of Roffredo Caeta-
ni, Duke of Sermoneta.
August 15, 1937 1

GREW, Alice. Wife of Joseph Clark Grew.
No date 1

GREW, Joseph Clark, 1880-1965. American diplomat.
January 18, 1929-August 19, 1955 12

GRIFFING, Robert P., Jr. American museum director.
May 2, 1956-September 4, 1956 4

GRIGGS, Maitland Fuller, 1872-1943. American art collector.
October 30, 1924-January 20, 1936 4

GRISCOM, Acton. American art collector.
July 17, 1928-August 23, 1928 2

GRONAU, Carmen. German-born English art historian, daughter-in-law of Georg Gronau and widow of Hans Dietrich Gronau.
November 11, 1951-November 21, 1957 4

GRONAU, Georg, 1868-1938. German art historian.
April 9, 1911-March 24, 1928 51
No date 60

GRONAU, Hans Dietrich, 1904-1950. German-born English art historian.
September 22, 1950-October 6, 1950 2

To NM:
November 12, 1950 1

GROPALLO, Marchesa Laura. Italian writer and playwright.
February 14, 1932 1
No date 6

GROUSSET, René, 1885-1952. French historian and orientalist.
January 14, 1937-April 15, 1946 3

GUALINO, Cesarina. Italian painter and wife of Riccardo Gualino.
December 13, 1945 1

GUALINO, Riccardo, 1879-1964. Italian industrialist, financier and art collector.
November 1, 1940 1

GUÉRARD, Albert Leon, 1880-1959. French-born American professor of literature.
December 13, 1950-November 27, 1951 3
No date 1

GUGGENHEIM, Olga. Wife of Simon Guggenheim, American politician and industrialist.
To MB:
No date 2

GUGGENHEIM, Solomon R., 1861-1949. American financier, art collector and philanthropist.
December 12, 1927 1

Written by his secretary or the secretary of the Guggenheim Foundation:
January 11, 1928-August 15, 1955 9

GUI, Vittorio, b. 1885. Italian conductor and composer.
August 19, 1947 1
No date 1

GUICCIARDINI, Count Paolo, 1880-1955. Florentine historian.
May 8, 1945 1

GUIDI, Giacomo, 1884-1936. Italian archaeologist.
June 10, 1935 1

GUIDOTTI, Gastone, b. 1901. Italian diplomat.
January 22, 1945-March 26, 1950 3

To NM:
December 12, 1940-May 2, 1957 3

GUIFFREY, Jean, b. 1870. French art historian and museum cu-
rator.
December 13, 1927 1

GUIGNET, M. M. French museum official.
December 7, 1948-January 7, 1949 2

GUILLOT DE SAIX. French writer.
No date 3

GULBENKIAN, Calouste Sarkis, 1869-1955. Turkish-born English
financier, art collector and philanthropist.
January 18, 1928-February 7, 1928 2

GUNNIS, Rupert. English civil servant and editor.
December 21, 1927-September 2, 1953 2

GUNTHER, Franklin Moth, b. 1885. American diplomat.
May 14, 1940-February 19, 1941 2

GUSTAF ADOLF VI, King of Sweden.
See: Sweden, King Gustaf Adolf VI of

GUTEKUNST, Otto. Former director of Colnaghi and Co., Ltd.,
London art dealers.
July 11, 1900-January 27, 1947 150

GUTTUSO, Mimise. Wife of Renato Guttuso.
No date 1

GUTTUSO, Renato, b. 1912. Italian painter.
December 26, 1950-December 1957 9
No date 1

GUYER, Samuel. Swiss archaeologist.
October 3, 1943 1

HABERFELD, Hugo. German art dealer.
November 13, 1928 1

HADELN, Hans von, 1878-1927. German art historian.
June 9, 1910-July 13, 1923 9

HAFFNER, F. German professor.
July 17, 1936-September 18, 1936 2

HAFTMANN, Werner, b. 1912. German art historian.
July 20, 1948 1

HAHNLOSER, Hans Rob, b. 1899. Swiss art historian and collector.
May 10, 1930-February 12, 1951 6

HALPERN, Barbara Strachey, b. 1912. Daughter of Oliver and Ra-
chel Strachey, granddaughter of Mary Berenson.
June 30, 1947-June 19, 1957 8

HALY, W. French writer.
December 31, 1932 1

HAMILTON, Carl W. American financier and art collector.
October 1, 1919-August 2, 1937 28
No date 1

HAMILTON, Hamish, b. 1900. English publisher and writer.
June 30, 1947-January 1, 1959 286
See also: Hand, Learned

HAMILTON, Yvonne. Born Marchesa Pallavicino, wife of Hamish
Hamilton.
June 28, 1951-February 12, 1958 8

HAMMER, Victor, b. 1882. Austrian-born American painter, type-
designer, printer and writer.
September 2, 1929-October 14, 1953 4

HAMMOND, Mason, b. 1903. American professor of Classics.
March 7, 1939-July 12, 1959 40

HAND, Frances, d. 1963. Wife of Learned Hand.
February 6, 1937-June 4, 1956 2
No date 3

To MB:
No date 1

HAND, Learned, 1872-1961. American jurist.
1931-1958 58

To Hamish Hamilton:
July 9, 1958 1

HAPGOOD, Charles Hutchins. American educator and son of Hutch-
ins Hapgood.
To MB:
July 2, 1924 1

HAPGOOD, Hutchins, 1869-1944. American writer and poet.
September 21, 1894-October 27, 1940 31
No date 34

HAPGOOD, Neith. Wife of Hutchins Hapgood.
July 22, 1906-December 10, 1927 11
No date 26

HARDING, Stan. Wife of German physician.
To MB:
No date 1

HARPER AND BROTHERS. New York publishers.
See: Canfield, Cass

HARRACH, Countess Helene, 1855-1961. Born Countess Arco Zin-
neberg, wife of Count Hans Harrach.
April 4, 1940-September 5, 1954 22
No date 36

HARRIS, Henry, d. 1950. English art collector.
January 6, 1928-January 20, 1930 2
No date 3

HARRISON, Anne (Nancy). Wife of Leland Harrison.
No date 1

HARRISON, Ethel. American acquaintance.
1911-September 2, 1914 3
No date 1

HARRISON, Leland, 1893-1951. American diplomat.
April 18, 1940-January 10, 1947 12

HARRSEN, Meta. American art historian.
February 2, 1932-May 18, 1958 90

HARTT, Frederick, b. 1914. American art historian.
December 1944-June 22, 1957 59

HARWOOD, Anthony. American poet.
February 14, 1951-March 14, 1952 5

HASELOFF, Arthur, 1872-1955. German art historian.
July 6, 1908-December 21, 1953 12

HASELTINE, Herbert, 1877-1962. American sculptor.
February 28, 1952-November 16, 1954 3

HASSALL, Joan, b. 1906. English painter and graphic artist.
August 29, 1950 1

HASSELL, Ilse von. Widow of Ulrich von Hassell, German diplomat.
February 27, 1934-January 12, 1956 13

HATHAWAY, Calvin Sutliff. American museum director.
July 29, 1948-November 21, 1956 3

HATTON, Marjorie. English writer.
December 16, 1946-October 29, 1958 10

HAUSER, Richard J. German-born English psychologist and socio-
logist.
July 27, 1957 1

HAUTECLOCHE, Jean de. French diplomat.
September 20, 1938 1

HAUTECOEUR, Louis, b. 1884. French art historian and museum
curator.
January 11, 1957 1

HAVEN, Joseph Emerson, 1885-1937. American diplomat.
December 27, 1920-January 27, 1937 17

HEIL, Walter, b. 1890. American museum director.
December 10, 1930-January 18, 1957 10

HEINEMANN, Rudolf J. German-American art dealer.
June 10, 1949-February 7, 1951 3

HELFER-BRACHET, B. French art restorer, employed by Duveen
Brothers.
November 9, 1930 1

HELEN, Queen of Rumania.
See: Rumania, Queen Mother Helen of

HELLER, Paul. German-born Canadian businessman.
October 1, 1953 1

HELLER, Wally. Wife of Paul Heller.
September 25, 1953 1

HEMINGWAY, Ernest, 1899-1961. American writer.
August 25, 1949-August 24, 1957 29

HEMINGWAY, Mary. Widow of Ernest Hemingway.
August 25, 1949-August 21, 1957 5

HENDY, Sir Philip, b. 1900. English art historian and museum
director.
October 14, 1926-January 25, 1952 10

HENRAUX, Albert S., 1881-1953. French museum director and
nephew of Carlo Placci.
June 6, 1925-September 25, 1946 9

HENRAUX, Elisabetta.
See: Piccolellis, Marchesa Elisabetta

HENRAUX, Lucien L., 1878-1926. French industrialist, art collector,
writer and nephew of Carlo Placci.
August 7, 1907-July 27, 1924 2

HERTZ, Henriette, 1846-1913. Founder of Hertziana Library in
Rome.
1899 1

HESELTINE, John Postle, 1843-1929. English draughtsman, etcher
and art collector.
February 11, 1917-May 11, 1920 3

HEURGON, Jacques. French archaeologist.
June 7, 1945-September 30, 1945 2
No date 2

HEYDENREICH, Ludwig Heinrich. German art historian.
May 6, 1945-June 29, 1948 5
No date 1
To NM:
March 2, 1946 1

HEYL, Bernard Chapman, b. 1905. American art historian.
June 26, 1948-May 10, 1954 3

HILL, Derek, b. 1916. English painter.
January 25, 1949-April 13, 1954 16
No date 41

HILL, Sir George Francis, 1867-1948. English archaeologist and
museum director.
April 28, 1905-August 2, 1947 14

HINKS, Roger, d. 1964. English art historian and museum official.
April 2, 1946-June 27, 1956 37

HIRSCH, Robert von. Swiss art collector.
April 29, 1937-January 15, 1953 5

HODGE, Philip. American government official.
November 24, 1957 1

HOFER, Frances. Wife of Philip Hofer.
June 16, 1949 1

HOFER, Philip, b. 1898. American bibliographer and book collector.

| December 22, 1933-November 6, 1958 | 97 |
| No date | 4 |

To NM:
| June 4, 1958 | 1 |

To Lawrence Berenson:
| October 21, 1952 | 1 |

HOFMANNSTHAL, Hugo von, 1874-1929. Austrian poet and playwright.
| No date | 2 |

To MB:
| March 31, 1928 | 1 |
| No date | 1 |

HOLMES, Sir Charles John, 1868-1936. English landscape painter, art critic and museum director.
| April 21, 1926-September 27, 1928 | 5 |

HOLMES, Edward Jackson, 1873-1950. American museum director.
| March 16, 1929 | 1 |

HOLROYD, Sir Charles, 1861-1917. English painter, etcher and museum director.
| June 16, 1906-January 5, 1917 | 5 |

HOPE-JOHNSTONE, John. English art collector and traveller.
| June 3, 1926 | 1 |

HORNE, Herbert Percy, 1864-1916. English architect, art historian and collector.
| January 9, 1899-May 1910 | 10 |
| No date | 8 |

To MB:
| No date | 1 |

HOROWITZ, Béla, 1903-1955. Austrian-born English publisher, founder of Phaidon Press in Vienna, now located in London.
| August 30, 1951-January 2, 1955 | 49 |

See also: Phaidon Press, Ltd.

HORTON, Marguerite. Patroness of music and daughter of Georges Wagnière, Swiss diplomat.
| December 29, 1937-May 11, 1956 | 26 |

HOUGHTON, Lord.

See: Whitman, Walt

HOURS, Magdeleine. French museum official.
 April 23, 1952-April 8, 1954 6

HOVEY, Richard Bennett, b. 1917. American literary critic and
 professor of English.
 June 3, 1952-June 26, 1952 2

HOWE, Mark Antony De Wolfe, 1864-1960. American writer.
 January 22, 1954-January 15, 1958 5

HOWE, Thomas Carr, b. 1904. American museum director.
 March 2, 1951-December 13, 1954 6

HOWES, Barbara. Pen name of Barbara Smith, American poet.
 January 28, 1951-March 17, 1958 8

HUBERT, Henri, 1872-1927. French ethnologist and anthropologist.
 May 18, 1920-August 16, 1921 2
 No date 3

HUBNER, Rachel. Israeli journalist.
 November 30, 1957-November 1, 1958 2

HUGELSHOFER, Walter. Swiss art collector and writer.
 To NM:
 March 6, 1948-December 18, 1957 5

HUNTINGTON, Archer Milton, 1870-1955. American writer and
 art collector.
 July 14, 1936-November 10, 1953 26
 To MB:
 January 1, 1923-June 9, 1928 2

HUNTINGTON, George Herbert, 1878-1953. President of Robert
 College, Istanbul.
 December 14, 1945-April 8, 1949 4

HUNTINGTON, Helen, d. 1950. Poet and novelist, first wife of
 Archer Milton Huntington, second wife of Harley Granville-Barker.
 No date 1

HURD, Richard Melancthon, 1865-1945. American art collector.
 January 27, 1928-June 24, 1937 5

HÜRLIMANN, Bettina. Wife of Martin Hürlimann.
 December 19, 1948-August 14, 1950 2

HÜRLIMANN, Martin. Director of Atlantis Verlag, Zürich pub-
 lishers.
 February 21, 1949 1
 To NM:
 March 14, 1950-March 27, 1950 2

HUTCHINSON, R. W., b. 1894. English archaeologist.
May 8, 1937-January 10, 1940 4

HUTHEESING, Krishna. Indian politician.
October 7, 1957 1

HUTTON, Edward, b. 1875. English writer and art connoisseur.
July 9, 1951-March 30, 1955 5
No date 8

To NM:
May 27, 1948-October 23, 1949 18

HUYGHE, René, b. 1906. French art historian and museum curator.
August 23, 1933-November 23, 1948 10
No date 2

HYDE, Louis F. American art collector.
February 5, 1924-June 18, 1924 4

INSEL-VERLAG.
See: Rössner, Hans

ISARLOV, Georges. French journalist and art critic.
May 7, 1934-February 9, 1935 2

IVINS, William Mills, Jr., 1881-1961. American bibliographer and
museum curator.
December 26, 1924-July 4, 1959 364

JACKSON, Lady.
See: Ward, Barbara

JAMES, Henry, 1843-1916. American novelist.
July 6, 1912-July 24, 1912 3

JAMES, William, 1842-1910. American philosopher and psychol-
ogist.
June 15, 1898-January 2, 1910 3

To Robert Pearsall Smith:
December 24, 1885 1

JAMES, William, 1882-1962. American painter and son of William
James, 1842-1910.
May 27, 1954 1

JEPHSON, Arthur Jermy Mounteney, 1858-1908. English writer and
traveller.
January 11, 1902-February 14, 1902 3
No date 1

To MB:
1901-December 29, 1907 3

JERPHANION, Guillaume de. French Jesuit archaeologist.
June 28, 1921-November 15, 1921 2

JIRMOUNSKY, Myron Malkiel, b. 1890. Russian art historian.
February 4, 1941-October 19, 1954 55

JOHNSON, Alvin Saunders, b. 1874. American economist and edu-
cator.
See: Part II a

JOHNSON, John Graves, 1841-1917. American lawyer and art
collector.
July 18, 1904-May 7, 1917 155
No date 44

JOHNSON, Robert Underwood, 1853-1937. American poet, editor,
philanthropist and diplomat.
November 4, 1920 1

JONES, Bob, Jr., b. 1911. President of Bob Jones University, Green-
ville, South Carolina.
September 30, 1953 1

JONES, Mary. Sister-in-law of Edith Wharton.
March 8, 1935 1

JOYCE, Stanislaus. Brother of James Joyce, Irish writer.
December 24, 1941-December 30, 1953 15

KAHN, Adèle, 1876-1949. Widow of Otto H. Kahn.
December 11, 1915-May 14, 1949 363
No date 80

KAHN, Otto H. American financier.
September 27, 1916 1

KAISER, Walter. American professor of literature.
June 30, 1956 1
No date 1

KANE, Amanda. Wife of Richmond Keith Kane.
July 16, 1951-October 11, 1957 12
No date 11

KANE, Richmond Keith, b. 1900. American lawyer.
June 16, 1953-January 24, 1955 3

KASSNER, Rudolf, 1873-1959. Austrian philosopher and writer.
January 27, 1920-August 28, 1954 12

KATAOKA, Hisashi. Japanese industrialist.
February 4, 1957 1

KATKOV, Georg. Russian historian and economist.
> August 16, 1933-January 1939 10
> No date 5

KATZ, Karl. Israeli museum director.
> May 1, 1958-September 7, 1958 2

KAY, Arthur. Scottish art collector and financier.
> June 21, 1934-January 18, 1938 5

KELEMEN, Pál, b. 1894. Hungarian-born American art historian and archaeologist.
> July 16, 1951-December 31, 1957 9

KEMP-WELCH, Alice. English writer.
> March 28, 1894 1

KENNEDY, Jacqueline Lee Bouvier. Widow of John F. Kennedy, former President of the United States.
> No date 10

KENYON, Sir Frederic George, 1863-1952. English archaeologist and museum director.
> August 12, 1946 1

KERENSKY, Alexander Fedorovitch, b. 1881. Russian statesman, head of provisional government, March-October 1917.
> October 27, 1920-February 18, 1927 2

KERR-LAWSON, Catherine. Wife of James Kerr-Lawson.
> May 8, 1939 1

KERR-LAWSON, James, 1864-1939. English painter.
> December 31, 1903-October 8, 1909 3

KESSELL, Mary. English painter.
> April 16, 1951-February 7, 1957 15
> No date 14

KEULENSTIERNA, K. Swedish art student.
> June 10, 1939-December 4, 1939 3

KEYSERLING, Count Hermann, 1880-1945. German philosopher and writer.
> 1911-1945 12

KHUEN BELASI, Countess Biba, 1891-1945. Daughter of Count Henry Lutzow, Austrian diplomat, wife of Count Carl Khuen Belasi.
> September 3, 1931-February 5, 1940 36
> No date 67

KHUEN BELASI, Count Carl, 1879-1963. Austrian landowner and
art student.
January 10, 1919-December 19, 1948 7

KIMBALL, Fiske, 1888-1955. American architect, museum director
and writer.
October 9, 1929-October 19, 1929 2

KING, Georgiana Goddard, 1871-1939. American art historian.
January 23, 1927-March 5, 1932 2

KIRK, Alexander Comstock, b. 1888. American diplomat.
July 22, 1933-February 9, 1946 14
No date 2

KIRSTEIN, Lincoln, b. 1907. American art and ballet critic, Di-
rector, New York City Ballet Company.
January 23, 1947-April 26, 1949 6

KLEINBERGER, F., Galerie. Franco-American art dealers.
December 20, 1909-February 11, 1946 172
No date 2

KNOPF, Blanche Wolf. Wife of Alfred A. Knopf, New York pub-
lisher.
November 18, 1948-March 31, 1958 32
To NM:
July 31, 1959 1

KNUDSEN, Edwin J. American journalist.
December 2, 1956 1

KOCHNITZKY, Léon. Polish-born Belgian writer and art critic.
May 29, 1949-August 31, 1951 6

KOECHLIN, Raymond, 1860-1931. French museum official.
October 15, 1924 1

KOESTLER, Arthur, b. 1905. Hungarian-born English novelist,
journalist and political essayist.
November 29, 1948-December 1, 1952 4

KOESTLER, Mamaine. Wife of Arthur Koestler.
December 26, 1949-May 29, 1951 4

KOKOSCHKA, Oskar, b. 1886. Austrian painter.
No date 2

KOLLEK, Theodore. Israeli government official.
February 7, 1955-June 11, 1957 2

KOSTYLEFF, N. Russian-born art connoisseur.
October 26, 1911 1

KRESS, Jonathan. Son of Rush Harrison Kress.
February 19, 1958-May 23, 1958 2

KRESS, Rush Harrison, 1877-1963. American art collector and
president of Samuel H. Kress Foundation, New York.
October 23, 1946-September 19, 1955 60
To NM:
January 3, 1947-May 15, 1947 5

KRESS, Samuel Henry, 1863-1955. American financier and art col-
lector, creator of Samuel H. Kress Foundation, New York.
March 12, 1937-April 19, 1946 33

KRESS, Virginia Watkins. Widow of Rush Harrison Kress.
January 19, 1955-September 1956 2

KRISTELLER, Paul Oskar, b. 1905. German-born American pro-
fessor of the history of philosophy.
November 29, 1933-May 9, 1947 3
No date 1

KROHN, Mario. Danish art critic.
October 12, 1908 1
No date 2

KÜHNEL, Ernst, 1882-1964. German orientalist.
1905-November 17, 1906 4

LA CAZE, Countess Gabrielle, d. 1929. French art connoisseur and
traveller.
1918-August 28, 1929 148
No date 12

LAFFAN, William Mackay, 1848-1909. American publisher, mu-
seum trustee, and art connoisseur.
September 25, 1904 1

LAGORIO, Henry J. Italo-American acquaintance.
February 8, 1951-March 4, 1952 2

LAMBE, Sir Charles Edward, 1900-1960. English admiral.
No date 1

LAMBE, Lesbia. Wife of Sir Charles Edward Lambe.
May 29, 1955 1
No date 3

LAMONT, Florence. Wife of Thomas William Lamont.
No date 5

LAMONT, Thomas William, 1870-1948. American philanthropist
and financier.
March 19, 1926-September 9, 1946 8

53

LANCKORONSKI, Leo Maria. German art historian.
 July 5, 1937 1

LANE, Arthur Bliss, 1894-1956. American diplomat.
 June 3, 1938-July 8, 1940 5

LANZ, Otto. Dutch physician and art collector.
 March 17, 1928-November 1, 1931 3
 No date 1

LAPSLEY, Eleanor Temple Emmet. Sister-in-law of Gaillard Lapsley.
 To Percy Lubbock:
 May 22, 1947 1

LAPSLEY, Gaillard, 1871-1949. American mediaevalist and literary
 executor of Edith Wharton.
 March 13, 1931-August 30, 1946 39
 To MB:
 April 3, 1939 1

LAURENTI, Cesare, 1854-1936. Italian painter.
 November 27, 1909-September 3, 1910 14
 No date 2

LAURIE, Arthur Pillans, 1861-1949. Scottish painter, art restorer
 and writer.
 September 1, 1925-September 4, 1925 2
 No date 1

LAVAGNINO, Emilio, 1898-1963. Member of Italian Fine Arts
 Administration.
 June 4, 1926 1

LAW, Ernest. English art historian.
 October 31, 1927-November 9, 1927 2

LAZAREV, Viktor Nikitich, b. 1897. Russian art historian.
 July 23, 1936 1
 No date 1

LAZZARONI, Baron Michele A. Italian art dealer and collector.
 June 15, 1909-July 2, 1929 43

LEACH, Nancy, b. 1923. American professor of literature.
 February 14, 1951-March 1, 1951 2

LEBLANC, Jean. French art historian and museum curator.
 August 8, 1948-February 10, 1951 9

LEDERER, Sandor. Hungarian art collector.
 October 7, 1906 1

LEE, Arthur Hamilton, Viscount Lee of Fareham, 1868-1947. English art collector and political figure.
June 5, 1924-December 3, 1932 8

LEE, Rensselaer Wright, b. 1898. American art historian.
January 24, 1930 1
No date 1

LEE, Vernon, 1856-1935. Pen name of Violet Paget, English essayist and musicologist.
January 8, 1894-March 5, 1929 2
No date 1

To MB:
No date 19

To NM:
No date 1

LEHMAN, Lee Anz Lynn (Kittie). Wife of Robert Lehman.
February 1, 1938 1
No date 1

LEHMAN, Philip, 1861-1947. American financier and art collector.
February 17, 1921 1
No date 2

LEHMAN, Robert, b. 1892. American financier and art collector, son of Philip Lehman.
September 28, 1929-February 24, 1958 40
No date 13

LEHMANN, Rosamond Nina. English novelist and first wife of Wogan Phillips, Baron Milford.
September 15, 1947-July 2, 1958 46
No date 3

LEIGH, Vivien, b. 1913. English actress.
March 24, 1947-July 27, 1957 6

LESLIE, Sir John Randolph Shane.
See: Leslie, Shane

LESLIE, Léonie, d. 1943. Mother of Shane Leslie.
January 24, 1910-March 1910 2
No date 6

LESLIE, Shane, b. 1885. Pen name of Sir John Randolph Shane Leslie, English writer.
October 19, 1949-December 4, 1949 2

LEVESQUE, Robert. French writer.
September 5, 1937-March 2, 1943 7

LEVI, Doro, b. 1898. Italian archaeologist, Director of Italian School of Archaeology, Athens.
March 30, 1934-March 25, 1953 12

LÉVIS MIREPOIX, Philomène de.
See: Sylve, Claude

LEVY, Louis. American lawyer.
April 29, 1926-March 1, 1950 78
To MB:
September 11, 1924-July 14, 1932 11
To NM:
March 30, 1938 1

LÉVY, Sylvain, 1863-1935. French sinologist.
February 18, 1927-January 12, 1929 2

LEWIS, Elizabeth. Second wife of Sir George Henry Lewis, English lawyer, and mother of Katherine Lewis.
See: Wilde, Oscar

LEWIS, Katherine, 1880-1961. Daughter of Sir George Henry and Elizabeth Lewis.
September 16, 1915-September 26, 1959 455
To MB:
October 12, 1932-October 13, 1936 2
To NM:
January 23, 1958-August 19, 1959 19

LEWIS, Sinclair, 1884-1951. American novelist.
February 16, 1949-July 17, 1949 3

LEWISOHN, Margaret, 1895-1954. American educator and wife of Sam A. Lewisohn, American financier and art collector.
July 17, 1953-June 5, 1954 4
No date 8

LIECHTENSTEIN, Prince Franz of. Art amateur.
January 25, 1917-March 17, 1920 2
No date 1

LINDSAY, Patrick, b. 1928. English art student, son of Lord Crawford.
September 2, 1952-June 1955 5
No date 4

LIPHART, Ernst Friedrich von, 1847-1932. Russian art historian and museum curator.
January 27, 1914-November 19, 1917 3
No date 1

LIPPMANN, Helen. Second wife of Walter Lippmann.
January 9, 1938-April 15, 1957 8

LIPPMANN, Walter, b. 1889. American political writer and journalist.
July 16, 1919-December 19, 1957 73
No date 32

To MB:
No date 3

LIVESEY, Rev. Herbert, b. 1892. Art collector.
No date 2

LLOYD, Michael. English writer.
October 9, 1952-March 22, 1953 3

LOCHOV, Nicolai, 1870-1948. Russian painter and art restorer.
January 4, 1929 1

LODGE, George Cabot, b. 1927. American government official.
No date 1

LOESER, Charles Alexander, 1864-1928. American art connoisseur and collector.
No date 1

LOESER, Olga. German-born pianist and widow of Charles Alexander Loeser.
June 7, 1928-January 15, 1942 39

LONDON, Hannah R. Pen name of Hannah London Siegel, American writer.
November 4, 1945-November 5, 1953 3

LONGHI, Roberto, b. 1887. Italian art historian.
September 4, 1912-December 11, 1956 14
No date 3

LONGMAN, Mark Frederic Kerr, b. 1916. Chairman of Longmans Green and Co., Ltd., London publishers.
December 18, 1953-January 19, 1954 2

LONGMANS GREEN AND CO., Ltd. London publishers.
See: Longman, Mark Frederic Kerr

LOO, Ching Tsai, 1880-1957. Head of C. T. Loo, Inc., New York art dealers.
January 4, 1949 1

LORAINE, Sir Percy, 1880-1961. English diplomat.
May 18, 1939-May 24, 1940 2

L'ORANGE, Hans Peter, b. 1903. Norwegian archaeologist.
May 13, 1936-August 4, 1952 5

LORIA, Arturo, 1902-1957. Italian poet, essayist and journalist.
August 30, 1941-September 10, 1955 9
No date 1
. To NM:
February 12, 1934-March 19, 1934 2

LOUISE, Queen of Sweden.
See: Sweden, Queen Louise of

LOVETT, Robert Morss, 1870-1956. American educator and writer.
March 16, 1937-April 27, 1937 2

LOWE, Elias Avery, b. 1879. American paleographer.
December 5, 1956-March 6, 1957 3

LOWELL, Robert Traill Spence, Jr., b. 1917. American poet.
March 11, 1952 1

LUBBOCK, Percy, 1879-1965. English writer.
August 24, 1920-July 10, 1949 13
To MB:
February 20, 1935-February 6, 1941 3
See also: Lapsley, Eleanor Temple Emmet

LUBBOCK, Lady Sybil, 1881-1943. Daughter of the Earl of Desart,
wife of Percy Lubbock, formerly married to Bayard Cutting and
Geoffrey Scott.
December 23, 1909-December 22, 1940 83
No date 8
To MB:
June 21, 1915-January 23, 1936 5
No date 3

LUBOMIRSKI, Sebastian. Polish art collector.
July 7, 1947 1

LUCE, Clare Booth, b. 1903. Playwright and diplomat, wife of
Henry Robinson Luce.
No date 1

LUCE, Henry, III. Son of Henry Robinson Luce and first wife,
Lila Hotz.
September 10, 1950-July 21, 1956 6

LUCE, Henry Robinson, b. 1898. American publisher and editor.
August 15, 1949-May 18, 1955 2

LUCE, Patricia.
See: Botond, Patricia

LUDRES, Madame B. de. French acquaintance.
April 19, 1932-March 30, 1943 4
No date 1

LUGT, Frits, b. 1884. Dutch art historian and collector.
November 5, 1927-October 25, 1937 4

LULING, Countess Marina. Daughter of Count Giuseppe Volpi,
Italian financier.
November 19, 1940-February 8, 1958 12
No date 4

LULING THOMPSON, Sylvia.
See: Thompson, Sylvia

LYDIG, Philip Mesier, d. 1929. New York acquaintance.
March 22, 1910-April 20, 1910 2

LYDIG, Rita de Alba de Acosta, d. 1929. Cuban-American writer
and art collector, wife of Philip Mesier Lydig.
March 10, 1910-July 20, 1910 7
No date 2

MacCARTHY, Sir Desmond, 1877-1952. Anglo-Irish journalist and
writer.
April 11, 1947 1
To MB:
July 11, 1932-April 30, 1939 2
No date 3

MacGREEVY, Thomas. Irish poet and museum director.
October 23, 1950-December 9, 1958 40
To NM:
April 4, 1958-March 5, 1959 3

MACK, Julian William, 1866-1958. American jurist.
January 11, 1933-March 9, 1938 3
To MB:
July 21, 1933 1

MACKAY, Clarence Hungerford, 1874-1938. American financier
and art collector.
February 6, 1925-March 6, 1925 2

MACKAY, Helen (Nellie), b. 1876. American writer.
January 28, 1939-March 5, 1950 4
No date 5

MACKOWSKY, Hans, 1879-1938. German art critic and writer.
November 30, 1898-May 13, 1899 3

MACLAGAN, Sir Eric Robert Dalrymple, 1879-1951. English art historian, museum director and writer.
March 11, 1910-April 21, 1950 74

To MB:
July 2, 1924-October 7, 1928 2

MACLAGAN, Helen Lascelles, d. 1942. Wife of Sir Eric Robert Dalrymple Maclagan.
September 9, 1938-May 7, 1939 2
No date 1

MACMILLAN, Sir Maurice Harold, b. 1894. English statesman and head of Macmillan and Co., Ltd., London and New York publishers.
January 4, 1948 1

MADAN, Marjorie. Widow of Geoffrey Madan, English writer.
June 25, 1950-January 20, 1952 6

MADARIAGA, Salvador de, b. 1886. Spanish historian and diplomat.
June 25, 1955-July 24, 1956 2

MAHON, Denis, b. 1910. Anglo-Irish art critic, writer and collector.
December 27, 1948-August 18, 1954 15

MAITRE, Cl. E. French writer.

To MB:
April 12, 1924 1

MAKRIDY, Bey. Turkish museum official.
December 26, 1929-July 7, 1936 5

MALAGUZZI VALERI, Francesco, 1867-1928. Member of Italian Fine Arts Administration and writer.
January 11, 1909-October 19, 1925 25

MALAVASI, Achille. Italian writer and journalist.
August 8, 1951 1
No date 1

MALAVASI, Olga. Russian-born wife of Achille Malavasi.
No date 1

MÂLE, Émile, 1862-1954. French art historian and writer.
June 10, 1926-August 29, 1932 2

MALKIEL-JIRMOUNSKY, Myron.
See: Jirmounsky, Myron Malkiel

MALLMANN, Gaston von. German art collector.
October 21, 1905 1

MALLON, Paul. French art collector.
February 20, 1933-February 2, 1934 3

MALVEZZI, Marchese Aldobrandino, 1881-1960. Italian historian.
July 5, 1926-May 5, 1945 3

MANSHIP, Paul, b. 1885. American sculptor.
March 16, 1921-October 3, 1953 7
No date 1

To MB:
January 22, 1930 1

MARAINI, Antonio, 1886-1964. Italian sculptor.
July 2, 1927-January 2, 1938 3

MARAINI, Fosco, b. 1912. Italian explorer and writer, son of Antonio Maraini.
December 4, 1949-November 28, 1950 3

To NM:
August 7, 1959 1

MARAINI, Yoi. English-born wife of Antonio Maraini, mother of Fosco Maraini.
March 22, 1912-April 5, 1913 8
No date 2

To MB:
No date 4

MARANGONI, Luigi, 1872-1950. Italian architect.
June 21, 1948 1

MARANGONI, Matteo, 1876-1958. Italian art historian and writer.
May 12, 1932 1

MARCEL, Gabriel, b. 1889. French philosopher.
June 13, 1950-January 14, 1955 2

MARCELLO, Count Girolamo. Italian art connoisseur.
May 27, 1934 1

MARCHIG, Giannino. Italian painter and art restorer.
July 26, 1947-January 11, 1953 8
To NM:
February 12, 1958 1

MARDERSTEIG, Giovanni. German-Italian printer, graphic artist and publisher.
November 9, 1955 1

MARGHIERI, Gino. Italian lawyer and husband of Clotilde Marghieri, Italian writer.
No date 1

MARIANO, Elisabetta (Nicky), b. 1887. From 1919 to 1959, librarian, secretary, and general assistant at I Tatti.
See: Part II c.

MARINOTTI, Paolo. Art historian and son of Franco Marinotti, Milanese financier and industrialist.
November 7, 1955 1

To NM:
January 3, 1956-February 23, 1956 2

MARITAIN, Jacques, b. 1882. French philosopher.
To Sir Robert Mayer:
November 9, 1954 1

MARKEVITCH, Igor, b. 1912. Russian-born composer and orchestra conductor.
April 1940-January 16, 1957 28
No date 1

MARKEVITCH, Topazia. Second wife of Igor Markevitch.
January 1, 1950-April 11, 1957 7
No date 3

MARKEVITCH, Vaslav, b. 1937. Swiss painter, son of Igor Markevitch.
January 20, 1944-September 27, 1957 10
No date 2

MARLBOROUGH, Gladys Deacon, Duchess of, b. 1921. Wife of Duke of Marlborough.
No date 25

MARONE, Gherardo, 1891-1962. Italo-Argentinian professor of Italian literature.
January 29, 1947-December 17, 1953 3

MARSH, Sir Edward Howard, 1872-1953. English writer and poet.
May 26, 1945-July 3, 1949 10

MARTIN, Sir Alec, b. 1884. Head of Christie's, London auction house.
July 17, 1939-February 4, 1958 8

MASEFIELD, John, b. 1878. English poet laureate.
May 4, 1915 1

MASSIGNON, Louis, 1883-1963. French orientalist and philosopher.
December 31, 1924-November 9, 1956 7

MATHER, Ellen, d. 1964. Wife of Frank Jewett Mather, Jr.
 December 7, 1949-December 2, 1958 7
 No date 2

MATHER, Frank Jewett, Jr., 1868-1953. American art historian.
 March 5, 1906-December 11, 1951 173
 No date 20

MATISSE, Henri, 1869-1954. French painter.
 March 6, 1909-December 6, 1909 3

MATTIOLI, Raffaele, b. 1895. Italian financier.
 August 3, 1955 1

MAUGHAM, William Somerset, b. 1874. English novelist.
 June 21, 1954-July 27, 1955 2

MAYER, August Liebmann, 1885-1945. German art historian and museum curator.
 February 2, 1920-October 18, 1927 4
 No date 1

MAYER, Leo Ary, b. 1895. Israeli art historian and orientalist.
 February 11, 1931-October 19, 1937 4

MAYER, Sir Robert, b. 1879. English philanthropist.
 November 17, 1954 1
 See also: Maritain, Jacques

MAYNE, Peter. English novelist.
 April 15, 1957-December 7, 1958 7

MAYOR, Alpheus Hyatt, b. 1901. American art historian and museum curator.
 January 30, 1940-August 1, 1956 10
 No date 2

MAYOR, Virginia. Wife of Alpheus Hyatt Mayor.
 April 25, 1929-March 1930 2
 No date 2

McANDREW, Elizabeth. Wife of John McAndrew.
 No date 6

McANDREW, John, b. 1904. American art historian.
 July 12, 1951 1

McCARTHY, Mary, b. 1912. American novelist.
 November 10, 1955-September 9, 1959 21
 To NM:
 August 21, 1959 1

McCOLL, Dugald Sutherland, 1859-1948. English museum curator and writer.
April 24, 1945-September 15, 1945 4

McCOMB, Arthur Kilgore, b. 1895. Canadian art critic and writer.
June 18, 1925-April 19, 1956 25

McCORMICK, Anne O'Hare. American journalist.
September 5, 1949-January 4, 1954 8

McCRAY, Porter A. American museum official.
July 5, 1954 1

McDONALD, James Grover, b. 1886. American political scientist.
See: Flexner, Abraham

McDOUGALL, John M. Manager of Chapman and Hall, Ltd., London publishers.
January 2, 1952-November 11, 1953 19

McILHENNY, Henry Plumer, b. 1910. American art collector and museum curator.
March 17, 1949-December 9, 1952 2

McKEAN, Margarett Sargent, b. 1892. American painter.
January 14, 1954-November 10, 1954 10

McLEISH, Archibald, b. 1892. American poet.
No date 1

McMASTER, Julian. Daughter of Ian McMaster, English diplomat.
August 10, 1957 1

MEDEA, Alba. Italian art historian.
October 11, 1940-June 4, 1943 5

MEIER-GRAEFE, Julius A., 1867-1935. German art critic and writer.
November 1, 1907 1

MEISS, Millard, b. 1904. American art historian.
March 24, 1947-February 23, 1953 6

MENDELSOHN, Louise. Wife of Eric Mendelsohn, German-American architect.
April 2, 1957 1

MENDL, Sir Charles, 1871-1958. English diplomat, husband of Elsie de Wolfe.
January 1, 1952-May 28, 1952 2

MENDL, Lady.
See: De Wolfe, Elsie

MERCATI, Gino. Italian byzantinist, brother of Cardinal Mercati.
December 5, 1924-February 26, 1925 3

MERZ, Charles, b. 1893. American journalist, writer and government official.
No date 2

METMAN, L. French writer.
August 15, 1937 1

MEYER, Agnes Elizabeth, b. 1887. American writer and journalist.
September 21, 1953-July 12, 1957 5

MEYER, Peter, b. 1894. Swiss art critic and journalist.
June 18, 1959 1

MIDDELDORF, Ulrich Alexander, b. 1901. German art historian.
June 29, 1945-July 11, 1953 3

MIETKE, Mary. English wife of Hungarian diplomat.
August 18, 1941-March 25, 1947 2

MILANI COMPARETTI, Luisa. Wife of Piero Milani Comparetti, son of archaeologist Milani, grandson of Domenico Comparetti, philologist.
August 14, 1950-August 7, 1955 6

MILLAR, Eric George, b. 1887. English museum curator.
December 30, 1923-January 10, 1926 3

MILLET, Gabriel, 1867-1953. French archaeologist.
November 27, 1923-August 19, 1924 2

MILLIKEN, William Mathewson, b. 1889. American museum director.
October 21, 1939-March 14, 1958 12
No date 4

MINER, Dorothy Eugenia, b. 1904. American museum curator.
January 21, 1938-October 11, 1938 5

MISSIROLI, Mario, b. 1886. Italian journalist and writer.
December 23, 1954-March 27, 1956 2

MIWA, Fukumatau. Japanese art student, pupil of Yukio Yashiro.
December 20, 1950-January 3, 1952 5

MODIGLIANI, Ettore, 1873-1947. Italian museum curator.
January 2, 1927 1

MOE, Henry Allen, b. 1894. American lawyer and foundation director.
May 24, 1955 1

MOGABGAB, Theo. English civil servant.
October 4, 1956-December 28, 1956 2

MOLAJOLI, Bruno, b. 1905. Director General of Italian Fine Arts
Administration.
March 12, 1928-March 10, 1954 2

MOLMENTI, Pompeo Gherardo, 1852-1928. Italian historian and
writer.
March 16, 1927-March 23, 1927 2

MOMMSEN, Theodor E., 1905-1958. German historian.
May 14, 1949-July 23, 1952 2

MONDADORI, Alberto. Son of Arnoldo Mondadori, Milanese publi-
sher.
February 18, 1946-November 19, 1949 19

MONGAN, Agnes, b. 1905. American museum curator and art
historian.
September 9, 1929-July 24, 1957 86
To NM:
November 16, 1954 1

MONGAN, Elizabeth. American art critic and museum curator.
September 17, 1951-July 12, 1952 3

MONTANELLI, Indro, b. 1909. Italian journalist and writer.
No date 1

MONTESQUIOU-FEZENSAC, Count Robert de, 1855-1921. French
writer.
1904-October 8, 1909 17
No date 11

MOORE, George, 1852-1933. Anglo-Irish novelist.
October 30, 1912 1
No date 2

MOORE, Henry Spencer, b. 1898. English sculptor.
June 17, 1948 1

MOORE, Lawrence. American educator.
December 26, 1958-August 11, 1959 2
To MB:
October 13, 1933-February 13, 1935 2
To NM:
March 21, 1959 1

MOORE, Thomas Sturge, b. 1870. English wood engraver and poet.
To MB:
July 8, 1924 1

MOOREHEAD, Alan McCrae, b. 1910. Australian-born English writer and journalist.

December 14, 1950-July 14, 1956	5
No date	2

MORASSI, Antonio, b. 1892. Italian art historian.

January 15, 1937-June 2, 1956	10

MORAVIA, Alberto, b. 1907. Italian novelist.

No date	4

MOREY, Charles Rufus, 1877-1955. American art historian.

September 20, 1945-August 16, 1953	8
No date	1

To NM:

November 24, 1948-December 24, 1948	2

MORGAN, Charles Langbridge, 1894-1958. English novelist.

July 17, 1949-July 18, 1950	3
No date	1

MORGAN, John Pierpont, 1837-1913. American financier, art collector and philanthropist, founder of Pierpont Morgan Library, New York.

April 6, 1909	1

MORONI FUMAGALLI, Paola. Associate Director of Electa Editrice, Milan publishers.

To NM:

December 19, 1949-February 28, 1959	17

MORRA DI LAVRIANO, Count Umberto, b. 1900. Italian writer.

June 24, 1928-June 18, 1956	38
No date	7

To MB:

August 19, 1925-July 25, 1940	20
No date	4

To NM:

February 2, 1926-February 4, 1926	2

MORRILL, Ferdinand Gordon, b. 1910. American architect and painter.

December 1946-January 21, 1950	3

To Charles Warren:

December 7, 1946	1

MORSHEAD, Sir Owen, b. 1893. English librarian.

December 31, 1934-February 10, 1936	2

MORTIMER, Raymond, b. 1895. English writer and journalist.
February 22, 1936-November 26, 1957 57
To NM:
June 14, 1959 1

MOSTYN-OWEN, William, b. 1929. English art connoisseur and
writer.
October 11, 1952-October 19, 1958 11
No date 13

MOULTON, Louise Chandler, 1835-1908. Boston acquaintance.
March 15, 1894 1

MOUTERDE, René, 1880-1962. French Jesuit archaeologist.
July 31, 1929 1

MUGNIER, Abbé Arthur, 1853-1944. French humanist, friend of
J. K. Huysmans.
August 28, 1919-December 7, 1939 34
No date 2

MUMFORD, Lewis, b. 1895. American writer and art critic.
March 31, 1954-January 1, 1958 3

MUNN, James Buell, b. 1890. American professor of English.
February 20, 1930-April 7, 1930 2

MUNNINGS, Sir Alfred, 1878-1959. English poet and painter.
November 28, 1953 1

MUNRO, Thomas, b. 1897. American educator and philosopher.
November 13, 1946 1

MUNTHE, Axel, 1857-1949. Swedish physician and writer.
October 5, 1916 1

MURATOV, Pavel Pavlovich, b. 1881. Russian art historian.
January 4, 1927-January 23, 1928 2

MURNAGHAN, James A. Irish art collector.
To MB:
October 20, 1927 1

MURRAY, Gilbert, 1866-1957. English professor of Classics and
writer.
June 16, 1904-February 26, 1954 3

MURRAY, Sir John, b. 1884. Director of John Murray, English
publishers.
February 19, 1951-August 31, 1955 3

NABOKOV, Nikolai, b. 1903. Russian-born American composer and
musicologist.
April 24, 1956 1

NAMIER, Julia. Wife of Sir Lewis Bernstein Namier.
November 14, 1953-May 23, 1956 4

NAMIER, Sir Lewis Bernstein, 1888-1960. Russian-born English historian.
October 3, 1951-February 6, 1956 9

NARKISS, Mordechai, b. 1898. Polish-born Israeli museum director.
May 25, 1952 1

To NM:
July 1, 1955-October 16, 1955 4

NEMES, Marczell von. Hungarian art collector.
July 19, 1924-August 20, 1927 3

To NM:
May 20, 1924-July 19, 1924 3

NERI, Dario, 1895-1958. Italian painter, founder of Electa Editrice, Milan publishers.
June 25, 1949-July 10, 1954 2

To NM:
June 18, 1949-August 25, 1956 8

NEUMANN, Heinrich von. Austrian laryngologist.
December 31, 1937-April 28, 1939 6

NEUMEYER, Alfred, b. 1901. German-born American art historian.
September 12, 1933-July 22, 1955 6

To NM:
September 21, 1949 1

NEURATH, Eva. Director of Thames and Hudson, Ltd., London publishers.
To NM:
July 2, 1957-December 19, 1958 10

NEUSNER, Jacob. American theologian.
May 21, 1957 1

To NM:
July 18, 1957 1

NEWELL, Gertrude. American acquaintance.
April 1, 1951-December 5, 1951 2

NEWMARK, Joseph D. Cousin of Bernard Berenson.
1954-June 14, 1956 6
See also: Wickenden, John F.

NEWMARK, Selma. Wife of Joseph D. Newmark.
1954 1

cont.

To NM:
No date 1

NICHOLS, Rose Standish, 1872-1960. American landscape gardener,
writer and traveller.

May 5, 1949-November 11, 1954 4
No date 2

NICHOLSON, Alfred, 1898-1964. American art historian and cousin
of Mary Berenson.

April 22, 1931-January 2, 1959 16
To MB:
October 3, 1935-November 27, 1944 2

NICHOLSON, Mary. Wife of Alfred Nicholson.
April 23, 1945 1

NICHOLSON, Mary (Molly). Wife of Reginald Popham Nicholson.
June 14, 1937-March 14, 1958 34
No date 1

NICHOLSON, Reginald Popham (Simon), 1874-1950. English colo-
nial official.
March 25, 1936-August 2, 1949 15

NICOLSON, Sir Harold, b. 1886. English diplomat, writer and
journalist.
December 20, 1938-November 23, 1956 15

NICOLSON, Lionel Benedict, b. 1914. English art critic, editor
of *The Burlington Magazine* and son of Sir Harold Nicolson.
June 11, 1937-August 12, 1955 20
No date 11

NICOLSON, Nigel, b. 1917. Member of Parliament, writer, director
of Weidenfeld and Nicolson Ltd., London publishers, and son
of Sir Harold Nicolson.
January 20, 1948 1

NICOLSON, Victoria.
See: Sackville-West, Victoria

NOAILLES, Viscount Charles de, b. 1891. French art connoisseur
and garden expert.
January 2, 1936-January 25, 1959 43

NOAILLES, Viscountess Marie Laure de. French writer and art
collector, wife of Viscount Charles de Noailles.
March 29, 1933-May 29, 1949 72
No date 1

To MB:
March 22, 1933-January 23, 1935 5

NOBLE, Michael Sinclair. English sculptor.
 May 2, 1945-April 9, 1952 4

 To NM:
 October 3, 1951-November 18, 1951 2

NORDHOFF, Sarah. American writer and cousin of Mary Berenson.
 February 4, 1945-August 1, 1945 2

NORRINGTON, Arthur Lionel Pugh, b. 1899. President of Trin-
 ity College, Oxford, writer, and Secretary of The Clarendon Press.
 November 10, 1927-February 16, 1953 27

 To NM:
 October 18, 1930-September 9, 1953 4

NORRIS, Christopher. English art collector, connoisseur and mu-
 seum official.
 November 27, 1945-October 31, 1956 5

NORTHROP, Catharine. Wife of George Norton Northrop.
 No date 1

NORTHROP, George Norton, 1880-1964. American educator and
 art collector.
 March 7, 1952-December 28, 1958 20

NORTON, Grace, b. 1834. American writer and poet.
 November 21, 1907 1
 No date 1

NORTON, Robert, d. 1939. English diplomat and painter.
 August 20, 1937 1
 No date 7

NOSEDA, Aldo. Italian art collector and connoisseur.
 November 24, 1909-March 17, 1911 5
 No date 13

OBRIST, Hermann, 1863-1927. German-English sculptor.
 November 28, 1907 1

 To MB:
 June 24, 1894-November 1, 1894 12
 No date 2

OFENHEIM, Wilhelm von. Austrian art collector.
 January 13, 1928-December 20, 1930 5

 To NM:
 May 16, 1928 1

OFFNER, Richard, 1889-1965. American art historian.
December 12, 1914-June 19, 1958 25

 To MB:
 May 16, 1922 1
 To NM:
 March 19, 1925 1

OJETTI, Fernanda. Widow of Ugo Ojetti.
March 27, 1945-June 10, 1955 10
 To NM:
 May 13, 1945-September 16, 1946 2

OJETTI, Ugo, 1871-1946. Italian journalist, literary critic, art collector and connoisseur, director of *Corriere della Sera,* 1919-1925.
January 27, 1912-April 28, 1941 49

OLGA, Princess of Yugoslavia.
See: Yugoslavia, Princess Olga of

OLIVIER, Sir Laurence, b. 1907. English actor and director.
May 3, 1953-July 11, 1953 2

OLSCHKI, Aldo, 1893-1963. Bibliographer and head of Casa Editrice Leo S. Olschki, Florence publishers.
January 14, 1951-November 26, 1955 4

OPPENHEIM, M. Austrian physician.
December 3, 1937 1

OREBAUGH, Walter William, b. 1910. American diplomat.
December 14, 1948-December 18, 1950 5

ORIGO, Marchesa Iris, b. 1902. Writer, daughter of Bayard Cutting and Lady Sybil Cutting Lubbock and wife of Marchese Antonio Origo.
July 30, 1930-April 6, 1957 16
No date 6

ORLANDO, Ambrogio, d. 1958. Son of Vittorio Emanuele Orlando.
November 18, 1941-December 28, 1946 3

ORLANDO, Count Rosolino. Mayor of Livorno in 1916.
See: Carmichael, Montgomery

ORLANDO, Vittorio Emanuele, 1860-1952. Italian statesman and jurist.
November 23, 1941-February 25, 1950 5

ORMESSON, Count Wladimir d', b. 1888. French journalist, writer, and diplomat, member of French Academy.
July 17, 1953-January 10, 1956 2

ORSAY, Francesca d'.
 See: D'Orsay, Francesca

ORTOLANI, Sergio, 1896-1949. Art historian and member of Italian Fine Arts Administration.
 May 4, 1945-March 10, 1949 4
 To NM:
 June 15, 1949-October 8, 1949 2

OSGOOD, Robert Treadwell, b. 1865. American educator and minister, Harvard classmate of Bernard Berenson.
 October 18, 1932 1

OUROUSSOFF, L. Russian exile in France.
 June 16, 1919 1
 To MB:
 April 26, 1919 1

OWEN, Richard. English art dealer and collector.
 May 30, 1928-April 9, 1937 3

PACH, Walter, 1883-1958. American artist, writer and art critic.
 September 5, 1924-February 3, 1955 21

PAGET, Violet.
 See: Lee, Vernon

PALAZZESCHI, Aldo, b. 1885. Italian novelist and poet.
 To MB:
 December 20, 1943 1

PALFFY, Dorothy, b. 1892. Sister of Gladys, Duchess of Marlborough.
 No date 1

PALMER, Bertha Honoré, 1849-1918. American civic leader, wife of Potter Palmer, Chicago realtor.
 November 2, 1909 1

PANE, Roberto, b. 1897. Italian professor of architecture.
 July 11, 1932-August 17, 1951 31
 No date 8

PANGE, Count Jean de. French art collector and writer.
 April 23, 1952 1

PANTHEON BOOKS, Inc., New York.
 See: Wolff, Kurt

PAOLINI, Paolo. Italian art dealer and collector.
 June 2, 1910-July 11, 1937 85
 No date 4

PAPAFAVA, Count Francesco, 1864-1912. Italian philosopher and economist.
December 26, 1901 1

PAPI, Roberto. Italian writer.
October 5, 1944-May 14, 1956 4

PAPINI, Livia Kuzmich. Hungarian-born sculptor and widow of Roberto Papini.
September 18, 1944 1

PAPINI, Roberto, 1883-1957. Italian professor of architecture.
January 14, 1923-December 23, 1956 8

PARSONS, Harold Woodbury, b. 1882. American art connoisseur.
August 12, 1912-July 26, 1958 130
To NM:
December 3, 1954-June 11, 1958 3
No date 2

PASQUIER, Ninette. Wife of director of French Institute, Naples.
February 28, 1951-November 13, 1953 16

PATRICOLO, Achille. Italian architect.
May 11, 1922-November 20, 1927 15

PAUL, Prince of Yugoslavia.
See: Yugoslavia, Prince Paul of

PEDRETTI, Carlo. Italian publisher, writer and bibliographer.
December 9, 1955-May 31, 1956 2

PELLEGRINI, Alessandro. Italian writer.
July 14, 1941-February 4, 1952 4

PERCIVAL, Elizabeth. Anglo-Irish ladies' maid employed at I Tatti, 1923-1940.
November 3, 1954 1
No date 3
To MB:
1937-October 18, 1942 4
To NM:
December 9, 1955 1

PERKINS, Frederick Mason, 1874-1955. American art connoisseur and collector.
July 25, 1900-December 11, 1954 84
No date 1
To MB:
March 24, 1901-April 26, 1914 40
No date 8

PERKINS, L. C. Mother of Frederick Mason Perkins.

August 16, 1904 1

To MB:
August 25, 1904-September 1, 1904 2

PERKINS, Lucy May Alcott. Wife of Frederick Mason Perkins.

To MB:
September 20, 1901-August 14, 1904 15

PEROWNE, Stewart, b. 1901. English historian, orientalist and civil
servant.

February 11, 1950-November 7, 1958 77

To NM:
December 9, 1958 1

PERRY, Bernard Berenson, b. 1910. Director of Indiana University
Press, son of Ralph Barton and Rachel Berenson Perry.

October 24, 1944-February 18, 1952 16
No date 1

PERRY, Lilla Cabot. Wife of Thomas Sargeant Perry.

July 20, 1928-January 27, 1930 4
No date 5

PERRY, Rachel Berenson, 1872-1933. Sister of Bernard Berenson
and wife of Ralph Barton Perry.

June 13, 1915-August 22, 1932 4
No date 1

To MB:
1905-August 29, 1933 7
No date 3

PERRY, Ralph Barton, 1876-1957. American professor of philosophy
and brother-in-law of Bernard Berenson.

August 21, 1912-December 23, 1954 55
No date 1

October 11, 1933 signed by:
Ralph Barton Perry, Paul Joseph Sachs, Edward Waldo Forbes
and George Harold Edgell 1

To MB:
August 3, 1931-July 13, 1938 7

To Elizabeth Berenson:
December 3, 1948 1

PERRY, Thomas Sargeant, 1845-1928. American writer, scholar and
educator.

March 24, 1894-October 12, 1923 40

PHAIDON PRESS, Ltd. London publishers, formerly located in Vienna.

February 15, 1955-August 28, 1959 20

See also: Horowitz, Béla

PHILLIPPS, Lisle March. English writer.

November 21, 1904 1

No date 2

PHILLIPS, Caroline, b. 1880. Wife of William Phillips.

January 2, 1939-February 8, 1950 12

No date 13

PHILLIPS, Sir Claude, 1846-1924. English art connoisseur and writer.

January 15, 1906-July 6, 1921 20

PHILLIPS, Duncan, b. 1886. American art connoisseur, collector, writer, museum director and founder of Phillips Gallery, Washington, D. C.

May 27, 1932-November 18, 1937 4

PHILLIPS, William, b. 1878. American diplomat.

1939-October 22, 1957 43

No date 7

PICCOLELLIS, Marchesa Elisabetta de, b. 1895. Widow of Lucien Henraux.

March 23, 1930-August 19, 1956 8

No date 11

PICKMAN, Edward Motley, 1886-1959. American philosopher and historian.

October 9, 1929-December 21, 1953 8

PICKMAN, Hester. Daughter of Margaret Chanler and wife of Edward Motley Pickman.

October 20, 1935-July 11, 1958 12

No date 12

To MB:

April 15, 1936 1

PIJOÁN Y SOTERAS, José, b. 1881. Spanish art historian.

December 8, 1952-May 14, 1958 11

No date 1

PINSENT, Cecil. English architect, responsible for enlarging Villa I Tatti and designing its gardens.

February 19, 1917-June 7, 1959 62

No date 1

cont.

To MB:
August 20, 1909-March 19, 1939 58

To NM:
January 23, 1959 1

PIOT, M. Wife of René Piot.

To MB:
July 8, 1910 1

PIOT, René, 1869-1934. French painter.
December 9, 1909-March 28, 1912 9
No date 19

To MB:
November 6, 1910 1
No date 2

To Carlo Placci:
December 28, 1910 1

PIOVENE, Guido, b. 1907. Italian journalist and novelist.
December 5, 1957-December 28, 1958 2

PITTALUGA, Mary. Italian art historian.
August 26, 1950-May 24, 1951 2
No date 2

PLACCI, Addie. Sister of Carlo Placci.

To MB:
December 26, 1917 1

PLACCI, Carlo, 1861-1941. Italian writer, Bernard Berenson's oldest friend in Italy.
January 4, 1896-August 9, 1939 79
No date 1

To MB:
January 10, 1904-December 12, 1940 35

To NM:
May 25, 1927 1
See also: Piot, René

PLANISCIG, Leo, 1887-1952. Austrian art historian and museum curator.
August 1, 1924-May 10, 1937 10

PLATT, Dan Fellows. American art collector and writer.
May 29, 1918 1

POGGI, Giovanni, 1873-1961. Italian writer and member of Italian Fine Arts Administration.
February 25, 1930-September 23, 1956 3

POGLAYEN-NEUWALL, Stephan. Austrian art critic.
July 29, 1927-March 4, 1928 2

To NM:
December 6, 1927-January 21, 1928 2

POLLAK, Ludwig, b. 1868. German art connoisseur.
July 3, 1935-December 4, 1936 5

POLOVTSOFF, Alexander. Russian-born art connoisseur and writer.
April 3, 1927-August 1, 1933 5

POPE, Arthur Upham, b. 1881. American art connoisseur and writer.
August 3, 1925-November 5, 1958 33

POPE-HENNESSY, James, b. 1916. English writer and biographer, brother of John Pope-Hennessy.
April 5, 1951-November 10, 1958 5
No date 3

POPE-HENNESSY, John Wyndham, b. 1913. English museum curator, art historian and writer, brother of James Pope-Hennessy.
January 10, 1950-January 3, 1959 26
No date 4

To NM:
July 22, 1958-May 20, 1959 3

POPHAM, Arthur Ewart, b. 1889. English museum curator and writer.
March 1, 1950-December 6, 1950 4

PORCELLA, Amadore. Italian art historian.
January 9, 1934-February 16, 1952 3

PORTEN, Jerome. Relative of Bernard Berenson.
March 23, 1956 1

PORTER, Arthur Kingsley, 1883-1933. American art historian.
August 27, 1917-June 19, 1933 95

To MB:
May 29, 1920-March 4, 1930 8

PORTER, Cole, 1893-1964. American composer.
August 31, 1950-May 23, 1957 4

PORTER, Linda Thomas, d. 1954. Wife of Cole Porter.
March 18, 1938-January 5, 1953 9
No date 10

PORTER, Lucy, 1876-1962. Wife of Arthur Kingsley Porter.
 October 19, 1923-October 13, 1954 55
 No date 1

 To MB:
 January 28, 1921-April 14, 1935 14

POST, Chandler Rathfon, 1881-1959. American art historian.
 August 13, 1926-August 15, 1932 4

POUNCEY, Philip Michael Rivers, b. 1910. English museum curator and writer.
 December 15, 1936-November 8, 1954 12

POUND, Ezra Loomis, b. 1885. American poet.
 March 13, 1927 1

PRAZ, Mario, b. 1896. Italian professor of English literature, writer and art collector.
 August 8, 1933-April 15, 1956 46
 No date 12

PRAZ, Vivyan.
 See: Volbach, Vivyan

PRESTON, Stuart, b. 1915. American journalist and art critic.
 September 10, 1940-February 21, 1949 11

PREZZOLINI, Giuseppe, b. 1882. Italian journalist, writer and professor of Italian literature.
 February 10, 1920-November 18, 1933 6

PRIESTLEY, Flora, 1859-1944. Irish-born resident of Florence.
 No date 1

PRIESTLEY, John Boynton, b. 1894. English novelist, playwright and essayist.
 August 2, 1949-October 15, 1953 2

PRINCE, Morton, 1854-1929. American philosopher and psychologist.
 To MB:
 April 1922 1
 No date 1

PUSEY, Nathan Marsh, b. 1907. President of Harvard University.
 February 8, 1954-June 11, 1958 4

QUAAS, Edward. President of *Wissenschaftliche Kunstverein*, Berlin.
 October 6, 1910 1

QUARONI, Pietro, b. 1898. Italian diplomat.
 December 15, 1954 1

RABINOWITZ, Louis Mayer, 1887-1957. American financier and art collector.
April 3, 1946 1

RADZIWILL, Princess Lee Bouvier. Wife of Prince Radziwill, sister of Jacqueline Bouvier Kennedy.
August 7, 1951-March 13, 1954 3

RAGGHIANTI, Carlo Ludovico, b. 1910. Italian art historian.
January 20, 1936-June 7, 1950 6

RAND, Edward Kennard, 1871-1945. American professor of Classics.
February 3, 1936-March 16, 1936 2

RANDALL-McIVER, David, 1873-1945. English archaeologist, anthropologist and writer.
December 27, 1928 1
No date 1

RANKIN, William. American archaeologist.
April 21, 1898-February 21, 1908 7

RAYNER, John. English writer.
April 26, 1945 1

RÉAU, Louis, 1881-1951. French art historian.
March 17, 1924-February 25, 1926 2

REBER, G. F. Swiss art collector.
February 2, 1937 1

REDMOND, Roland Livingston, b. 1892. American lawyer and museum trustee.
May 21, 1957 1

REED, Henry Hope, b. 1915. American historian of architecture.
July 18, 1954-March 7, 1956 4

REINACH, Salomon, 1858-1932. French archaelogist and humanist.
August 21, 1900-January 25, 1932 28
No date 8

To MB:
October 25, 1899-May 7, 1932 43
No date 12

REINHARDT, George Frederick, b. 1911. American diplomat, Ambassador in Rome since 1961.
August 28, 1937-October 29, 1939 3

REMBELINSKI, C., d. 1909. Polish art collector.
January 15, 1908-July 19, 1909 7

To MB:
February 14, 1905 1

RHEIMS, Lili. Daughter of Alice Cramer, later Baroness Guy de Rothschild, and wife of Maurice Rheims.
July 18, 1955-July 10, 1958 8
No date 9

RHEIMS, Maurice. French writer and art connoisseur.
December 7, 1956 1

RHINELANDER, F. W. American art collector.
No date 6

RICCI, Corrado, 1858-1934. Art historian, writer and member of Italian Fine Arts Administration.
April 25, 1903 1

RICH, Daniel Catton, b. 1904. American museum curator and art historian.
February 19, 1952-January 20, 1954 2

RICHARDSON, Edgar Preston, b. 1902. American museum director and writer.
April 21, 1948-October 28, 1954 8

RICHES, H. T. English collector of illuminated manuscripts.
October 15, 1923-March 27, 1927 15

RICHTER, Gisela, b. 1882. English-born American archaeologist, daughter of Jean Paul Richter.
May 13, 1936-June 2, 1956 25

RICHTER, Jean Paul, 1847-1937. German-born English art historian.
March 30, 1894-March 3, 1904 43
No date 1
To MB:
August 23, 1906 1

RICKERT, Margaret, b. 1888. American art historian.
April 29, 1953-September 16, 1956 4

RICKETTS, Charles de Sousy, 1866-1931. English art critic, painter and stage-designer.
To MB:
No date 4

RICORDI, OFFICINE GRAFICHE. Branch of Casa Editrice Ricordi, Milan publishers.
To NM:
February 5, 1960-May 8, 1961 17
See also: Valcarenghi, Guido

RIDDLE, Elizabeth. Wife of Sturgis Lee Riddle.
No date 1

RIDDLE, Sturgis Lee, b. 1909. American Episcopal minister.
July 7, 1949-October 31, 1956 13

RIEFSTAHL, Elizabeth. American Egyptologist, wife of Rudolf
Meyer Riefstahl.
1931-April 11, 1956 7

RIEFSTAHL, Rudolf Meyer, 1880-1936. German-born American art
historian and writer.
July 1, 1927-September 11, 1934 34
No date 2
To MB:
July 14, 1929-March 29, 1930 2
To NM:
July 15, 1929 1

RITTER DE ZÁHONY, Baroness Françoise, b. 1883. Born Fénélon
de Salignac, widow of Baron Piero Ritter de Záhony.
August 30, 1944-July 10, 1958 63
No date 18

RIVIÈRE, Georges Henri, b. 1897. French art critic and writer.
January 30, 1931-February 7, 1949 3

RIVIÈRE, Madame Georges Henri.
See: Stevens, Nina de Garmo

RIZZO, Giulio Emanuele, 1865-1950. Italian archaeologist.
May 20, 1940-November 13, 1944 8

ROBBINS, Julia, d. 1918. American writer and lecturer.
No date 3

ROBERTSON, John Mackinnon, 1856-1933. English writer and
politician.
February 14, 1903 1

ROBILANT, Count Andrea di. Son of Count Edmondo di Robilant.
June 4, 1927 1

ROBILANT, Count Edmondo di. Piedmontese resident of Venice.
August 4, 1928 1

ROBILANT, Countess Valentine di. Born Princess Windischgraetz,
wife of Count Edmondo di Robilant.
May 19, 1925 1

ROBINSON, Edward, 1858-1931. American museum director.
August 27, 1909-January 29, 1930 13

ROBINSON, Elizabeth. Wife of Edward Robinson.
May 14, 1931 1
No date 2

ROCCHI, Mariano. Italian art dealer, writer and collector.
No date 1

ROCKEFELLER, Abby Aldrich, d. 1948. Wife of John Davison
Rockefeller, Jr.
March 3, 1927 1

ROCKEFELLER, John Davison, Jr., 1874-1960. American financier.
To Margaret Scolari Barr:
August 13, 1948 1

ROGER-MARX, Claude, b. 1888. French art critic and writer.
December 28, 1955-August 18, 1959 5
No date 1

ROGNEDOV, Alexandre. Russian-born patron of the theater and
lecturer.
June 1953-June 2, 1953 2

ROHR, Nora Lee. American journalist.
To NM:
November 26, 1950 1

ROLLAND, Marie Romain. Widow of Romain Rolland, French
novelist.
September 4, 1951-November 29, 1951 2

ROLO, Charles J. American journalist and literary critic.
September 5, 1949-March 5, 1950 3

ROMANO, Giorgio. Israeli journalist.
April 15, 1950-May 8, 1950 2

RONZY, Pierre, b. 1883. French professor of literature and former
head of French Institute, Florence.
January 21, 1948 1
To Stojan Tzonev:
January 21, 1948 1

RORIMER, James J., b. 1905. American museum curator.
August 29, 1955-November 26, 1956 2

ROSE, Billy, b. 1899. American journalist and theatre producer.
April 26, 1949 1

ROSELIEP, Rev. Raymond. English clergyman.
January 13, 1950-February 16, 1950 2

ROSENBERG, Léonce Alexandre, d. 1947. French art dealer.
April 25, 1911-August 8, 1916 32
To MB:
April 6, 1912 1

83

ROSENBERG, Saemy. German-born American art dealer.
October 28, 1946-December 10, 1954 5

ROSENFELD, Eva M. English acquaintance.
May 18, 1955 1

ROSENTHAL, Erwin Isak Jakob. German-American bibliographer
and rare book dealer.
June 24, 1920-January 25, 1956 4

ROSS, Denman Waldo, 1853-1935. American educator and art
collector.
August 24, 1909-September 1928 6

To MB:
February 21, 1920-July 10, 1933 4

ROSS, Marvin Chauncey, b. 1904. American art critic, historian
and museum curator.
July 5, 1946 1

ROSS, Robert, 1869-1918. English art critic and writer.
November 25, 1907-December 18, 1909 3

ROSSI, Filippo, b. 1892. Art historian, writer and member of Italian
Fine Arts Administration.

To NM:
April 23, 1952 1
No date 1

ROSSI, Mario Manlio. Italian journalist.
No date 1

RÖSSNER, Hans. Manager of Insel-Verlag, Wiesbaden publishers.
May 9, 1953 1

ROSTOVTZEFF, Michael Ivanovich, 1870-1952. Russian-born Amer-
ican Classicist.
February 12, 1932-March 29, 1943 5

ROTHENSTEIN, Sir John, b. 1901. English museum director and
writer, son of Sir William Rothenstein.
July 20, 1938-May 4, 1959 2
No date 3

ROTHENSTEIN, Sir William, 1872-1945. English painter.
February 1, 1925-February 15, 1933 3

ROTHSCHILD, Baroness Alix de. Born Alix Schey, former wife
of Guy de Rothschild.
January 5, 1949-July 2, 1956 13
No date 7

ROTHSCHILD, Anthony de, b. 1887. English financier.
March 14, 1928-September 19, 1949 2

ROTHSCHILD, Baroness Germaine de. Art collector, widow of
Baron Edouard de Rothschild and mother of Baron Guy de
Rothschild.
March 17, 1954-March 4, 1958 10
No date 5

ROTHSCHILD, Baroness Liliane de. Art collector, wife of Baron
Elie de Rothschild.
March 22, 1957-April 11, 1958 2

ROTHSCHILD, Baron Maurice de, b. 1881. French art collector,
son of Baron Edmond de Rothschild.
No date 2

ROUVIER, Jean. French diplomat and writer.
November 7, 1938-May 31, 1957 28
No date 62

ROWLEY, George, b. 1892. American museum curator and writer.
January 20, 1954-June 28, 1957 3
No date 1

RUBENSTEIN, Louis Urban. Relative of Bernard Berenson.
March 28, 1955 1

RUBOW, Jørn. Danish museum director.
May 21, 1949 1

RUFFINI, Nina. Journalist and writer, daughter of Francesco Ruf-
fini, Italian historian.
October 21, 1940-January 7, 1955 21

RUFFINO, Titina Martini, 1867-1959. Daughter of Ferdinando Mar-
tini, Italian statesman.
May 19, 1939-February 7, 1947 4

RUKHMABAI. Indian philanthropist.
February 25, 1950-January 29, 1952 3

To MB:
November 26, 1914-February 28, 1936 10

To Alys Russell:
November 8, 1940 1

RUMANIA, Queen Mother Helen of. Born Princess Helen of Greece,
former wife of King Caroll of Rumania, daughter of King Con-
stantine of Greece.
February 17, 1959 1

85

RUSPOLI, Princess Marta. Daughter of Marquis de Chambrun, former wife of Prince Ruspoli.

January 18, 1935-July 5, 1953 11
No date 6

RUSSELL, Alys, 1867-1951. Sister of Mary Berenson and first wife of Bertrand Russell.

April 17, 1903-January 16, 1951 106

To Lawrence Berenson:
July 19, 1940 1

To Martha Carey Thomas:
December 17, 1925 1

See also: Rukhmabai
 Shaw, George Bernard
 Thomas, Martha Carey
 Trevor-Roper, Hugh Redwald
 Wharton, Edith
 Whitman, Walt
 Zangwill, Edith

RUSSELL, Bertrand, b. 1872. English philosopher and mathematician.

November 26, 1901-June 4, 1954 7

To MB:
June 21, 1911 1

RUSSELL, Edith Finch.
See: Finch, Edith

RUSSELL, John. English journalist.
April 29, 1950-November 28, 1954 6

SABAVALA, Shirin. Wife of Jehangir Sabavala, Indian painter.
No date 1

SACHS, Arthur. American financier and art collector.
December 17, 1927-May 13, 1954 9

SACHS, Meta. Wife of Paul Joseph Sachs.
No date 1

SACHS, Paul Joseph, 1878-1965. American educator, art historian, writer, art collector and museum director.
January 4, 1916-February 8, 1955 81

To John Walker:
March 4, 1939 1

See also: Perry, Ralph Barton

SACKVILLE-WEST, Victoria, 1892-1962. Pen name of Victoria Nic-
olson, novelist, wife of Sir Harold Nicolson.
No date 1

SALLES, Georges Adolphe, b. 1889. French art critic, collector and
museum director.
July 20, 1941-July 24, 1954 9

SALM, Count Christian, b. 1906. Austrian art historian and museum
curator.
September 14, 1936-January 8, 1951 11

SALMI, Mario, b. 1889. Italian art historian.
July 10, 1924-March 1, 1934 8
No date 1

To Baroness Alda Anrep:
March 27, 1956 1

SALTER Ethel. Wife of Baron James Arthur Salter, English econ-
omist and statesman.
September 25, 1950-November 17, 1951 3

SALTONSTALL, John Lee, Jr. American lawyer and politician.
May 15, 1937-July 8, 1937 2

SALTZMAN, Charles Eskridge, b. 1903. American financier.
December 11, 1946-April 11, 1949 2

SALVEMINI, Fernande. Wife of Gaetano Salvemini.
October 6, 1918-October 9, 1918 2

To MB:
September 17, 1918 1

SALVEMINI, Gaetano, 1873-1957. Italian historian.
August 27, 1903-October 6, 1922 7
To MB:
September 6, 1922-November 11, 1925 9
To NM:
July 30, 1957 1
See also: Burlingham, Charles Culp

SAMUELS, Ernest, b. 1903. American professor of literature.
July 12, 1955-December 27, 1958 5
To NM:
April 5, 1956 1

SANMINIATELLI, Count Bino. Italian novelist and journalist.
January 8, 1937-March 4, 1952 3

SANTAYANA, George, 1863-1952. Spanish-born American philosopher, essayist and novelist.

November 22, 1925 1

To MB:
November 25, 1904-March 10, 1930 3
No date 1

SARFATTI, Margherita Grassini. Italian journalist and writer.

June 9, 1937-October 21, 1957 65
No date 7

SARGENT, Elizabeth. Niece of a Boston University classmate of Bernard Berenson.

November 18, 1949-December 12, 1949 2

SARRE, Friedrich, 1865-1945. German scholar, art collector and museum curator.

November 3, 1922-July 16, 1937 9

SARTON, May, b. 1912. Belgian-born American poet and novelist.

September 9, 1954 1

SASSOON, Aline, d. 1909. Wife of Sir Edward Albert Sassoon, daughter of Baron Gustave de Rothschild.

1906-September 2, 1908 25
No date 40

SAVINIO, Alberto, b. 1891. Pen name of Andrea De Chirico, Italian writer and painter, brother of Giorgio De Chirico, painter.

May 19, 1951-June 4, 1951 2

SAVOIA, Marie José of, b. 1906. Wife of Umberto II, ex-King of Italy, daughter of King Leopold of Belgium.

October 2, 1946-August 1958 12
No date 2

SAXL, Fritz, 1890-1948. German-born English scholar, former head of Warburg Institute.

November 13, 1930-September 17, 1945 6

SCARETTI, Marjorie, b. 1903. English painter, widow of Roman financier Enrico Scaretti and sister of Sir Gladwyn Jebb, English diplomat.

December 28, 1944-October 20, 1945 11
No date 2

SCHAPIRO, Meyer, b. 1904. Lithuanian-born American art historian and writer.

January 27, 1929-March 10, 1953 3

SCHARF, Alfred, b. 1900. German-born English art historian and collector.
October 14, 1952 1

SCHARY, Dore, b. 1905. American motion picture producer and playwright.
July 19, 1957 1

SCHINASI, Leon, 1890-1930. American art collector.
No date 1

SCHLIEFFEN-RENARD, Anne von.
See: West, Robert

SCHLOSSER, Julius von, 1866-1938. Austrian art historian.
July 1, 1926-November 12, 1930 3

SCHLUMBERGER, Gustave, 1844-1929. French byzantinist.
No date 1

SCHMARSOW, August, 1853-1936. German art historian.
January 15, 1900 1

SCHNEIDER, Daniel Edward, b. 1907. American physician and writer.
September 22, 1952-February 22, 1954 6

SCHORER, Mark, b. 1908. American professor of literature.
February 16, 1954-March 6, 1957 3
To NM:
April 10, 1957 1

SCHRAFL, A. Swiss oculist and art collector.
December 9, 1946-December 8, 1948 4
To NM:
June 4, 1952 1

SCHUSTER, Max Lincoln, b. 1897. Head of Simon and Schuster, New York publishers.
October 16, 1951-March 30, 1958 56

SCHWARZENBERG, Erkinger. Son of Prince Johannes Schwarzenberg and student of archaeology.
No date 2

SCHWARZENBERG, Prince Johannes, b. 1903. Austrian diplomat.
February 15, 1954 1

SCHWARZENBERG, Princess Kathleen. Belgian wife of Prince Johannes Schwarzenberg.
July 1937-1948 7
No date 23

SCOTT, Geoffrey, d. 1929. English writer.
 September 17, 1911 1
 No date 1

 To Edith Wharton:
 November 24, 1916 1

SCOTT, Marie Louise. American-born former wife of Marquis de Sinçay, then wife of Archibald Scott.
 September 18, 1937-January 27, 1951 5

SCOTT, Lady Sybil.
 See: Lubbock, Lady Sybil.

SCRINZI, Alessandro. Italian art historian and museum director.
 August 11, 1945 1

SEDGWICK, Francis Minturn, b. 1904. American sculptor and art collector.
 October 17, 1951-November 11, 1951 2

SEILERN, Count Antoine von, b. 1901. Austrian art collector.
 August 29, 1952-September 20, 1952 2

SELIGMAN, Germain, b. 1893. Franco-American art dealer and writer, son of Jacques Seligmann.
 April 18, 1949-January 5, 1956 16

SELIGMANN, Arnold, d. 1932. French art dealer, brother of Jacques Seligmann.
 December 4, 1916-July 28, 1927 9

SELIGMANN, Jacques, 1858-1923. Head of French firm of art dealers.
 October 30, 1907-December 28, 1922 32

SELLERS, Eugénie.
 See: Strong, Eugénie Sellers

SENHOUSE, Roger Henry Pocklington, b. 1899. English writer.
 May 28, 1947 1

SERAO, Matilde, 1856-1927. Italian journalist and writer.
 August 27, 1904-August 20, 1906 3

SERLUPI CRESCENZI, Marchese Filippo, b. 1900. Italian lawyer, art collector, and diplomat.
 October 27, 1957 1

 To NM:
 April 18, 1950 1

SERLUPI CRESCENZI, Marchesa Gilberta. Daughter of Baroness Françoise Ritter de Záhony and wife of Marchese Filippo Serlupi Crescenzi.
 No date 1

SERRISTORI, Countess Hortense, 1871-1960. Spanish-born writer and wife of Count Umberto Serristori, Italian art collector.

1902-December 22, 1956 37
No date 11

To NM:
No date 1

SERVICE, Richard Montgomery, b. 1914. American diplomat.
November 9, 1956-November 25, 1957 2

SEZNEC, Jean Joseph, b. 1905. French professor of literature.
June 26, 1939-September 22, 1955 20
No date 2

SFORZA, Count Carlo, 1873-1952. Italian diplomat and statesman.
February 13, 1947-May 27, 1951 5
No date 5
See also: Frankfurter, Felix

SHAPLEY, Fern Rusk, b. 1890. American art historian and museum curator, wife of John Shapley.
June 9, 1940-February 27, 1957 13

To MB:
July 30, 1938-September 1, 1938 2

To NM:
August 4, 1954 1

SHAPLEY, John, b. 1890. American art historian.
February 6, 1937-October 5, 1939 3

SHAW, George Bernard, 1856-1950. English writer.
See: Russell, Alys

SHEEAN, James Vincent, b. 1899. American journalist and writer.
No date 1

SHERIDAN, Clare Consuelo, b. 1885. English sculptor and writer.
September 29, 1946 1

SHERMAN, Frederic Fairchild, 1874-1940. American publisher.
September 9, 1912-October 16, 1929 54

To MB:
May 29, 1915 1

SHIELDS, Rosella. American acquaintance.
April 25, 1949-January 10, 1955 7

SHINCHOSHA COMPANY, Tokyo.
See: Kataoka, Hisashi

SHIPPEN, Eugene Rodman, b. 1865. American Unitarian minister and poet.
May 8, 1951-July 1, 1951 2

SIEGEL, Hannah London.
See: London, Hannah R.

SIFF, Philip. American acquaintance.
May 14, 1954-July 9, 1954 2

SIMKHOVITCH, Vladimir Gregorievitch, b. 1874. Russian-born art historian and collector.
February 12, 1933-October 23, 1950 4

SIMONSON, Lee, b. 1888. New York set designer and writer.
No date 1

SIMONY, Count Reynald de, b. 1909. French international civil servant.
February 17, 1944-June 29, 1955 3
No date 1

SINCLAIR, Gregg Manners, b. 1890. American professor of English literature and president of Oriental Institute, Hawaii.
April 11, 1951-March 9, 1959 12

SIRÉN, Osvald, b. 1879. Swedish art historian.
December 5, 1902-February 23, 1955 17

SITWELL, Sir Osbert, b. 1892. English novelist, poet and essayist.
November 2, 1947 1

SIZER, Theodore, b. 1892. American art historian.
March 16, 1928-June 21, 1958 27

SMIRNOFF, A. Russian byzantinist.
November 17, 1928 1

SMITH, Barbara.
See: Howes, Barbara

SMITH, Frank Channing, Jr., 1877-1952. American lawyer, business executive and art collector.
July 16, 1921-May 16, 1938 4

SMITH, Logan Pearsall, 1865-1946. American-born English writer, brother of Mary Berenson.
March 24, 1908-November 3, 1918 2
To MB:
March 22, 1908-February 27, 1928 4
See also: Wallas, Audrey
 Whitman, Walt

SMITH, Robert Pearsall. Father of Mary Berenson.
 See: James, William
 Whitman, Walt

SMITH, William Jay. American poet, husband of Barbara Howes.
 October 19, 1950-August 1, 1951 3

SMYTH, Craig Hugh, b. 1915. American art historian, director of
Institute of Fine Arts, New York.
 December 11, 1957 1

SMYTH, Dame Ethel Mary, 1858-1944. English composer and writer.
 May 17, 1920 1

SORBELLO, Uguccione Ranieri di. Italian journalist and diplomat.
 November 27, 1945-October 2, 1950 2
 No date 1

SPENDER, Stephen, b. 1909. English poet, essayist and editor of
journal, *Encounter*.
 September 5, 1956-October 11, 1956 2

SPIRIDON, Joseph. French art collector.
 December 13, 1905 1

SPRIGGE, Cecil Jackson Squire, 1896-1959. English journalist and
writer.
 December 29, 1947-December 5, 1955 3
 To NM:
 December 29, 1947 1

SPRIGGE, Sylvia. English writer and journalist, widow of Cecil
Jackson Squire Sprigge.
 See: Part II a

STACKELBERG, Traugott von. German-Baltic writer and physician.
 September 23, 1956 1

STANG, Ragna Thiis. Daughter of Jens Thiis, Norwegian art
historian.
 April 1, 1952-July 17, 1952 2

STARK, Freya, b. 1893. English writer and traveller.
 April 1, 1946-July 31, 1958 99

STAUDE, Hans Joachim, b. 1904. German painter.
 August 12, 1938-December 31, 1938 2

STCHERBACHEVA, Marie I. Russian museum curator.
 August 25, 1955-December 25, 1956 3

STECHOW, Wolfgang, b. 1896. German-born American art historian.
 December 20, 1955-July 5, 1956 4

STEEGMAN, John E. H., b. 1899.　Anglo-Canadian museum director.
January 9, 1952-January 31, 1952　　　　　　　　　　2

STEEGMULLER, Francis, b. 1906.　American writer.
November 3, 1949-January 16, 1955　　　　　　　　　4

STEIN, Sir Aurel, 1862-1943.　Hungarian-born English explorer and archaeologist.
June 19, 1925-May 18, 1939　　　　　　　　　　　16
To MB:
March 4, 1920　　　　　　　　　　　　　　　　1

STEIN, Leo, 1872-1947.　American painter, writer and psychologist, brother of Gertrude Stein.
1907-September 17, 1945　　　　　　　　　　　12
No date　　　　　　　　　　　　　　　　　1
To MB:
November 29, 1925-March 2, 1937　　　　　　　　2
No date　　　　　　　　　　　　　　　　　6

STEIN, Nina.　Widow of Leo Stein.
August 12, 1947-December 1, 1947　　　　　　　　2

STEINBECK, John Ernest, b. 1902.　American novelist.
May 7, 1957　　　　　　　　　　　　　　　　1

STEINBERG, Leo, b. 1920.　American art historian.
March 5, 1958-May 10, 1958　　　　　　　　　　2

STEINERT, Sylvia Curtis, b. 1899.　Daughter of Ralph Curtis.
July 1, 1934　　　　　　　　　　　　　　　　1

STEINMANN, Ernst, 1866-1934.　German art historian, former head of Hertziana Library, Rome.
April 8, 1904-February 22, 1934　　　　　　　　54
No date　　　　　　　　　　　　　　　　　2
To MB:
1925-January 4, 1932　　　　　　　　　　　　6

STEPHEN, Karin, 1890-1953.　English psychologist, daughter of Mary Berenson by former marriage to Frank Costelloe, wife of Adrian Stephen and sister-in-law of Virginia Woolf.
July 22, 1912-March 18, 1951　　　　　　　　　9
No date　　　　　　　　　　　　　　　　　4

STEPHENS, Jean Johnson.　American acquaintance.
September 15, 1939-February 16, 1940　　　　　　3

STERLING, Charles, b. 1901.　French art critic and museum curator.
January 7, 1937　　　　　　　　　　　　　　1

STETTLER, Michael, b. 1913. Swiss architect and museum curator.

To NM:
February 18, 1957 1

STEVENS, Nina de Garmo. American-born writer, wife of Georges
Henri Rivière.
January 16, 1931-May 21, 1931 2

STEVENSON, Adlai Ewing, 1900-1965. American statesman.
July 6, 1953-August 25, 1958 2
See also: Darvall, Frank Ongley

STILLMAN, Chauncey Devereux, b. 1907. American financier and
art collector.
December 28, 1938 1

STOCLET, Adolphe, 1871-1949. Belgian financier and art collector.
December 29, 1926-September 8, 1945 2

To NM:
August 1, 1926 1

STOCLET, Suzanne. Wife of Adolphe Stoclet.
November 1, 1945-December 29, 1946 2
No date 1

STOGDON, Edgar, 1870-1951. English clergyman, educator and art
amateur.
December 11, 1947 1

STORRS, Sir Ronald, 1881-1955. English diplomat.
September 20, 1922-April 19, 1955 20

To MB:
October 9, 1930-1947 5

STRACHEY, Barbara.
See: Halpern, Barbara Strachey

STRACHEY, Christopher, b. 1916. English scientist, son of Oliver
and Rachel Strachey, grandson of Mary Berenson.
September 26, 1956 1

STRACHEY, Giles Lytton, 1880-1932. English critic and biographer.
To MB:
April 14, 1921 1

STRACHEY, Rachel (Ray), 1887-1940. English writer, daughter of
Mary Berenson by former marriage to Frank Costelloe, wife of
Oliver Strachey.
October 6, 1935-July 19, 1938 25
See also: Thomas, Martha Carey

STRAUS, Percy Selden, 1876-1944. American financier, art collector and philanthropist.
September 28, 1926-March 29, 1934 17

STROGANOFF, Y. Russian art collector.
July 27, 1909 1

STRONG, Charles Augustus, 1862-1940. American philosopher and psychologist.
September 3, 1907-March 6, 1908 2
To MB:
May 1, 1923-February 1, 1936 2

STRONG, Eugénie Sellers, 1860-1943. English archaeologist and art historian.
April 3, 1894-December 28, 1941 15
To MB:
November 17, 1895-February 27, 1941 34

STRONG, Sandford Arthur, 1863-1904. English orientalist and art historian.
March 24, 1894 1

STUART, Sir Campbell, b. 1885. English editor, writer and art collector.
April 23, 1954-October 8, 1955 2

STUBBS, Kenneth, b. 1907. American art historian.
January 4, 1951-June 10, 1951 5

STUYVESANT, Rutherford, 1842-1909. American art collector.
April 16, 1904-January 12, 1908 9

SUARDI, Antonia. Italian acquaintance.
April 9, 1894 1

SUIDA, William Emil, 1877-1959. Austrian-born American art historian.
February 25, 1934-July 14, 1950 5

SULLEY, Arthur Joseph. English art dealer.
October 1, 1910-August 30, 1928 175
To MB:
January 11, 1917-January 18, 1929 75

SWARZENSKI, Georg, 1876-1957. German-born American art historian and museum curator.
August 21, 1910-April 16, 1952 7
To NM:
August 11, 1924 1

SWEDEN, King Gustaf Adolf VI of, b. 1882. Crown Prince of
Sweden until 1950, King of Sweden since 1950.

February 4, 1924-July 17, 1959 153

To NM:
August 28, 1958-June 3, 1959 3

SWEDEN, Queen Louise of, 1889-1965. Born Lady Louise Mount-
batten, wife of King Gustaf Adolf VI of Sweden.

October 13, 1952-September 30, 1958 3

To MB:
February 23, 1936 1

To NM:
October 1, 1958 1

SYLVE, Claude. Pen name of Philomène de la Foret Divonne,
French writer, born Philomène de Lévis Mirepoix.

January 2, 1921-January 14, 1949 65
No date 52

To MB:
June 1, 1931 1
No date 7

TAGLIABUE, John. Italo-American poet.

July 7, 1951-July 17, 1951 2

TAGORE, Sir Rabīndranāth, 1861-1941. Indian philosopher and poet.

June 13, 1913-July 24, 1913 2

To MB:
January 25, 1925 1

TAUBE VON DER ISSEN, Baron Otto, b. 1879. German-Baltic
poet and novelist.

February 8, 1950-November 18, 1957 7

TAYLOR, Alicia Cameron. Assistant to Jean Paul Richter.

To MB:
October 3, 1904-October 11, 1904 2
No date 8

TAYLOR, Annabel. Wife of Myron Charles Taylor.

August 25, 1937-August 1941 9
No date 1

TAYLOR, Francis Henry, 1903-1957. American art historian and
museum director.

July 5, 1949-October 17, 1957 10

97

TAYLOR, Myron Charles, 1874-1959. American financier and diplomat.

May 4, 1934-August 4, 1939	11
No date	2

TAYLOR, Pamela. Widow of Francis Henry Taylor.

October 25, 1955-March 3, 1958	9

TAYLOR, Rebecca Nicholson. American writer and relative of Mary Berenson.

To MB:

November 27, 1934	1

TEMKIN, Shlomo, b. 1902. Israeli official.

April 5, 1951-November 2, 1951	4

TEPLOW, Leo. American labor expert.

June 13, 1948	1

TEREY, Gabor. Hungarian art historian and museum director.

June 22, 1905-April 26, 1926	10

TESTI, Laudedeo. Italian art historian.

June 6, 1909-January 19, 1910	3

THACHER, John Seymour, b. 1904. American art historian and museum director.

August 3, 1938-June 7, 1956	8

THAMES AND HUDSON, Ltd., London.

See: Neurath, Eva.

THIIS, Jens Peter, 1870-1942. Norwegian art historian.

July 17, 1903-April 19, 1935	5
No date	2

THOMAS, Martha Carey, 1857-1935. American educator and college president, cousin of Mary Berenson.

March 20, 1921	1

To MB:

July 20, 1916-January 8, 1935	5

To Alys Russell:

January 29, 1918-February 15, 1935	6
No date	1

To Rachel Strachey:

November 21, 1924	1

See also: Russell, Alys

THOMPSON, Daniel Varney, b. 1902. American scientist and writer.
February 12, 1930-November 30, 1957 104

To MB:
April 29, 1935 1
To Margaret Forbes:
December 5, 1938 1
See also: Barlow, Samuel Latham Mitchell
 Bell, Hamilton
 Constable, William George
 Forbes, Margaret
 Greene, Belle da Costa

THOMPSON, Dorothy, b. 1894. American journalist and writer,
former wife of Sinclair Lewis.
January 22, 1952-February 19, 1953 2

THOMPSON, Sylvia, b. 1902. Pen name of Sylvia Luling Thomp-
son, English novelist.
June 30, 1936-March 20, 1959 44
No date 6

THOMSON, David Croal, 1855-1930. English art dealer and writer.
December 1, 1906-June 8, 1910 50

THOMSON, Lockett. English art dealer, son of David Croal
Thomson.
September 22, 1930 1

THOROLD, Algar, d. 1936. English writer.
September 26, 1932 1
No date 2

To MB:
January 6, 1905-February 9, 1925 7
No date 3

THOROLD, Theresa. English writer and wife of Algar Thorold.
To MB:
December 28, 1924-March 26, 1937 4

THORP, Augusta. American writer.
1890 1

THURN UND TAXIS, Prince Alexander, 1851-1939. Austrian land-
owner, philanthropist and musicologist.
March 1, 1934-January 3, 1935 2

THURN UND TAXIS, Princess Mary, 1855-1934. Wife of Prince
Alexander Thurn und Taxis.
August 19, 1905-July 30, 1928 9

cont.

To MB:
March 21, 1926-May 24, 1928 2

THURN VALSASSINA, Countess Elsa. Daughter of Count Henry Lützow, Austrian diplomat.
January 13, 1948-February 10, 1948 2

THYSSEN-BORNEMISZA, Baron Heinrich, 1875-1947. German financier and art collector, founder of Thyssen Museum, Lugano.
See: Part II a

TIETZE, Hans, 1880-1954. Austrian art historian.
May 22, 1926-June 19, 1948 4

TIETZE-CONRAT, Erika, 1883-1958. Austrian art historian, wife of Hans Tietze.
June 27, 1933 1

TIKKANEN, Johan Jakob. Finnish art historian.
July 10, 1924 1

TISSERANT, Cardinal Eugène, b. 1884. French prelate.
October 29, 1932-February 7, 1935 3

TITTLE, Walter, b. 1883. American painter and draughtsman.
April 11, 1954-May 7, 1954 2

TOEPLITZ, Ludovico. Italian financier.
January 28, 1931 1

TOESCA, Elena Berti. Italian art historian, wife of Pietro Toesca.
July 27, 1956-October 9, 1958 3

TOESCA, Pietro, 1877-1962. Italian art historian and writer.
January 14, 1920-October 28, 1958 311
 To MB:
 June 23, 1938 1
 To NM:
 August 6, 1928-July 25, 1958 2

TOLL, Nicholas Peter. Russian archaeologist and director of Kondakov Institute, Prague.
August 15, 1939-September 25, 1939 2

TOLNAY, Charles de, b. 1899. Hungarian-born American art historian.
February 26, 1928-October 1, 1928 2

TONE, Aileen. American secretary-companion of Henry Adams.
No date 1

TORMAY, Cecile. Hungarian novelist.
August 5, 1909-January 26, 1913 2

TOVEY, Sir Donald Francis, 1875-1940. English composer and professor of music.

To MB:
No date 1

TOWSLEY, Prentice W. American engineer and philosopher.
July 4, 1957-August 14, 1957 2

TREFUSIS, Violet. Anglo-French novelist.
August 8, 1950 1

TRENCH, Herbert, 1865-1923. Anglo-Irish poet.

To MB:
April 1, 1917 1

TREVELYAN, Elizabeth. Dutch-born wife of Robert Calverley Trevelyan.
July 6, 1946-July 12, 1958 15
No date 7

TREVELYAN, George Macaulay, b. 1876. English historian, brother of Robert Calverley Trevelyan.
See: Part II a

TREVELYAN, Robert Calverley, 1872-1951. English poet.
October 19, 1898-December 3, 1950 50

To MB:
May 11, 1920-February 10, 1936 9
No date 1

To Lady Colefax:
May 22, 1947 1

TREVOR-ROPER, Hugh Redwald, b. 1914. English historian.
August 29, 1947-August 13, 1958 80
To NM:
December 3, 1955-July 6, 1959 5
To Alys Russell:
October 3, 1947 1

TREVOR-ROPER, Lady Alexandra. Daughter of Field Marshal Haig, wife of Hugh Redwald Trevor-Roper.
August 4, 1953-October 31, 1955 13

TROTTER, Elizabeth. Secretary of Booth Tarkington, American writer.
June 8, 1935-February 1, 1938 5

TRUELLE, Jacques. French diplomat.
January 10, 1933-April 24, 1945 46
No date 16

TRUMAN, Harry S., b. 1884. Former President of the United States.
 June 27, 1956-March 8, 1958 5

TUCCI, Giuseppe, b. 1894. Italian orientalist.
 January 10, 1939-April 15, 1959 5
 No date 7

TURNER, Louis. Physicist, son-in-law of Frank Jewett Mather, Jr.
 December 2, 1958 1

TURNER, Margaret (Peggy). Daughter of Frank Jewett Mather, Jr.
 November 17, 1953 1

TVEDE, Mogens. Danish landscape architect.
 December 28, 1950 1

TYLER, Elisina. Wife of Royall Tyler.
 August 11, 1937 1

TYLER, Royall, 1884-1953. American writer and art collector.
 February 23, 1923-December 23, 1937 19

TYPALDO FORESTIS, Lela. Widow of Greek diplomat.
 June 26, 1952 1

TZONEV, Stojan. Bulgarian government official.
 See: Ronzy, Pierre

VAIČIULAITIS, Antanas. Lithuanian-born French art critic.
 April 12, 1937-February 7, 1945 6

VALCARENGHI, Guido, b. 1893. Director of Casa Editrice Ricordi,
 Milan publishers.
 April 13, 1956-October 31, 1956 8
 To NM:
 October 4, 1956-December 1956 2

VALENTINER, Wilhelm Reinhold, 1880-1958. German-born Amer-
 ican art historian and museum curator.
 October 10, 1912-March 12, 1946 17

VALÉRY, Paul, 1871-1945. French poet and literary critic.
 January 1, 1933-April 10, 1933 2

VANDERVELDE, Lalla. Writer and widow of Emile Vandervelde,
 Belgian politician.
 December 13, 1926-January 2, 1950 5

VAN MARLE, Raimond, 1887-1936. Dutch art historian.
 December 25, 1919-May 7, 1936 34

VAVALÀ, Evelyn Sandberg, d. 1961. English art connoisseur and
writer.
January 1927 1
No date 9

VENIER, Ottaviano. Italian art collector.
To NM:
October 19, 1948-September 11, 1957 9

To William George Constable:
September 11, 1957 1

VÉNIZÉLOS, Eleutherios, 1864-1936. Greek statesman.
No date 1

VENTURI, Adolfo, 1856-1941. Italian art historian.
March 20, 1910-March 4, 1941 20

VENTURI, Franco. Italian historian, son of Lionello Venturi.
December 5, 1949 1

VENTURI, Lionello, 1885-1961. Italian art historian, son of Adolfo
Venturi.
April 27, 1908-November 3, 1956 50

VENTURI, Maria. Widow of Adolfo Venturi.
February 21, 1941-December 29, 1941 3

VERGANI, Orio, 1899-1960. Italian journalist, writer and literary
critic.
February 28, 1951 1
No date 1

VERGARA-CAFFARELLI, Ernesto, 1907-1961. Italian archaeologist,
member of Italian Fine Arts Administration.
August 10, 1955 1

VERTOVA, Giacomo, b. 1888. Italian philosopher and educator,
father of Luisa Nicolson Vertova.
December 24, 1954 1

VERTOVA, Luisa Nicolson, b. 1920. Italian art historian and
writer.
September 8, 1947-April 1958 63

VEZZETTI, Anacleta Candida, b. 1886. Italian-born American pro-
fessor of literature and philosophy.
July 24, 1948 1

VIERECK, Peter, b. 1916. American poet and historian.
January 4, 1946-September 10, 1953 26
No date 7

VIGNIER, Charles, 1863-1934. French art collector and dealer.
October 28, 1911-December 23, 1930 55

VILMORIN, Louise de, b. 1902. French novelist and poet.
March 7, 1949 1

VINCENT, Sir Edgar.
See: D'Abernon, Viscount

VISCONTI-VENOSTA, Enrico, 1883-1945. Italian writer and son of
Marchese Emilio Visconti-Venosta, diplomat.
May 6, 1921-October 16, 1937 7

VISCONTI-VENOSTA, Giovanni, 1887-1947. Italian diplomat, son
of Marchese Emilio Visconti-Venosta and brother of Enrico Vis-
conti-Venosta.
No date 3

VISSON, André. Russian-born American journalist.
December 11, 1953-February 15, 1957 3

VITRY, Paul, 1872-1941. French art historian.
March 20, 1929 1

VOLBACH, Vivyan. English novelist, former wife of Mario Praz,
then wife of Wolfgang Friedrich Volbach.
October 31, 1947-March 19, 1953 4
No date 2

VOLBACH, Wolfgang Friedrich (Fritz), b. 1892. German art histo-
rian and museum director.
October 15, 1940-March 6, 1953 37
To NM:
February 3, 1948-November 11, 1950 2
See also: Bliss, Robert Woods

VOLPI, Elia. Italian art dealer and collector.
April 24, 1906-October 10, 1915 7

VOLPI, Countess Nerina, d. 1942. Wife of Count Giuseppe Volpi,
Italian financier.
1940-July 31, 1941 2
No date 1

VOSS, Hermann, b. 1884. German art historian.
August 23, 1939-September 1, 1955 3

WAGLÉ, Premila. Daughter of Indian diplomat Rao and wife of
Nitya Waglé, Indian civil servant.
No date 7
To Lionel Fielden:
February 18, 1955 1

WALDMAN, Milton, b. 1895. American-born English author and
 publisher, literary adviser for William Collins Sons and Co., Ltd.,
 London publishers.
 March 16, 1956 1
 To NM:
 September 7, 1956-November 5, 1956 2
WALEY, Arthur David, b. 1889. English writer, translator and
 orientalist.
 January 1, 1949-December 27, 1949 3
 No date 11
WALKER, John, b. 1906. American museum director.
 See: Sachs, Paul Joseph
WALKER, Lady Margaret. Daughter of Sir Eric Drummond, later
 Earl of Perth, wife of John Walker.
 December 16, 1939 1
WALLAS, Audrey. Widow of Graham Wallas, English sociologist
 and political scientist.
 To Logan Pearsall Smith:
 August 21, 1932 1
WALLER, George Platt, b. 1889. American diplomat.
 November 17, 1950-November 8, 1952 2
WALTER, Bruno, 1876-1962. German-born orchestra conductor.
 July 25, 1938-April 26, 1946 12
WALTERS, Henry, 1848-1931. American financier and art collector,
 founder of Walters Art Gallery, Baltimore.
 September 16, 1909-January 8, 1919 53
WANSBROUGH, Father Joseph, b. 1934. Benedictine monk.
 July 15, 1957 1
WARBURG, Felix Moritz, 1871-1937. German-born American finan-
 cier, philanthropist and art collector.
 June 16, 1925-1929 4
WARD, Barbara, b. 1914. English economist, sociologist and writer,
 wife of Sir Robert Jackson, government official.
 May 9, 1949-June 21, 1950 3
WARD PERKINS, John Bryan, b. 1912. English archaeologist and
 director of British School in Rome.
 March 6, 1948-January 13, 1953 2
WARNER, Langdon, 1881-1955. American archaeologist and orien-
 talist.
 October 6, 1930 1
 No date 1

WARREN, Charles, 1868-1954.　American lawyer.
See: Morrill, Ferdinand Gordon

WARREN, Edward Perry, 1860-1928.　American writer and art collector, one of Bernard Berenson's first sponsors during his years at Harvard.
March 28, 1894-June 23, 1917 36
To MB:
January 20, 1905-January 29, 1907 4

WASHBURN, Gordon Bailey, b. 1904.　American art historian and museum curator.
June 7, 1934-April 13, 1953 7

WATERFIELD, Gordon.　English journalist and writer, son of Lina Waterfield.
February 25, 1947 1

WATERFIELD, Lina, b. 1874.　English journalist and writer.
To MB:
January 15, 1927 1

WATERHOUSE, Ellis Kirkham, b. 1905.　English art historian, director of Barber Institute, Birmingham.
December 10, 1952 1

WATTEVILLE, Vivienne de.　Pen name of Vivienne Goschen, Swiss writer.
March 9, 1936-May 25, 1957 3
No date 3
To MB:
No date 1

WEBB, Sidney, 1859-1947.　English Socialist and historian.
To MB:
April 10, 1893 1

WEHLE, Harry Brandeis, b. 1887.　American art historian and museum curator.
June 23, 1936-February 1, 1952 4

WEIDLÉ, Wladimir, b. 1895.　Russian-born French writer and art amateur.
September 26, 1939-January 9, 1955 11

WELLER, Allen Stuart, b. 1907.　American art historian.
November 3, 1939-April 10, 1953 3

WELLER, George Anthony, b. 1907.　American journalist.
No date 1
To NM:
No date 1

WELLES, Sumner, 1892-1961. American statesman.
 December 13, 1945-January 13, 1951 7

 To Lawrence Berenson:
 April 13, 1949 1

WELLESZ, Egon Joseph, b. 1885. Austrian-born English musician.
 January 15, 1939 1

WELTY, Eudora, b. 1909. American novelist.
 October 31, 1950-August 8, 1954 2
 No date 2

WENDELL, Barrett, 1855-1921. American professor of literature and
 writer.
 February 17, 1901-September 5, 1920 41

 To Ralph Curtis:
 February 4, 1912-November 16, 1919 5
 See also: Gardner, Isabella Stewart

WENDLAND, Hans. German art dealer and collector.
 February 9, 1926-May 6, 1932 4

WENT, Catharina. Widow of Friedrich Went, Dutch botanist.
 April 10, 1949 1

WERFEL, Alma Mahler. Widow of Gustav Mahler, composer, and
 of Franz Werfel.
 April 1, 1938-October 9, 1952 6

WERFEL, Franz, 1890-1945. Austrian-born poet, novelist and play-
 wright.
 January 16, 1938-January 25, 1938 2

WESCOTT, Glenway, b. 1901. American writer.
 December 30, 1952 1

WEST, Rev. Arthur George Bainbridge, 1864-1952. English clergy-
 man and writer.
 December 27, 1892-January 1, 1949 3

WEST, Rebecca, b. 1892. Pen name of Cicily Andrews, English
 novelist and journalist.
 November 6, 1952-February 12, 1954 2
 No date 1

WEST, Robert, b. 1875. Pen name of Anne von Schlieffen-Renard,
 German writer and translator.
 October 19, 1924-April 20, 1927 2

WESTPHAL, Dorothee. German art historian.
 November 21, 1934 1

cont.

To NM:
November 21, 1934 1

WHARTON, Edith, 1862-1937. American novelist.
September 1909-April 9, 1937 428
No date 4

To MB:
1909-December 28, 1936 178
No date 1

To NM:
February 28, 1930-June 5, 1932 6

To Alys Russell:
August 12, 1926 1

See also: Cortissoz, Royal
 Scott, Geoffrey

WHITE, Alfred. General agent of Edith Wharton.
August 19, 1937 1

WHITE, Lawrence Grant, 1887-1956. American writer and architect,
son-in-law of Margaret Chanler.
April 18, 1949 1

WHITE, Michael Morgan. American acquaintance.
No date 1

WHITEHEAD, Anne, d. 1957. English acquaintance.
May 10, 1950-December 15, 1955 9

WHITEHILL, Walter Muir, b. 1905. American museum director,
librarian and writer.
July 15, 1929-December 20, 1956 13

WHITMAN, Walt, 1819-1892. American poet.
To MB:
July 27, 1884-November 18, 1890 35

To Lord Houghton:
June 20, 1885 1

To Alys Russell:
April 22, 1889 1

To Logan Pearsall Smith:
June 26, 1887-August 12, 1890 3

To Robert Pearsall Smith:
March 4, 1884-June 20, 1890 12

WICKENDEN, John F. Canadian contractor.
To Joseph D. Newmark:
May 21, 1956-June 12, 1956 3

WICKFELD, Monica de. Wife of Danish diplomat.
 December 15, 1942 1
 No date 1

WICKHOFF, Franz, 1853-1909. Austrian art historian.
 February 21, 1894-April 8, 1894 2
 No date 1

WIDENER, Joseph Early, 1872-1943. American financier and art collector.
 November 23, 1908-March 5, 1912 7

WILDE, Johannes, b. 1891. Hungarian-born English art historian.
 May 15, 1934-January 12, 1936 3

WILDE, Oscar. English writer.
 To Elizabeth Lewis:
 June 1882 1
 No date 1

WILDER, Thornton Niven, b. 1897. American novelist and playwright.
 January 5, 1945-April 7, 1950 3

WILEY, John, b. 1893. American diplomat.
 November 2, 1939 1

WILMERDING, Jane. Wife of Lucius Wilmerding, friend of Walter Lippmann.
 1937-December 15, 1937 3

WILPERT, Monsignor Giuseppe, 1857-1944. German prelate and archaeologist.
 December 30, 1934 1
 To MB:
 September 15, 1924 1

WINLOCK, Herbert Eustis. American Egyptologist and museum director.
 November 4, 1935 1

WINSLOW, Henry, b. 1874. Anglo-American painter.
 September 14, 1936-January 24, 1937 2

WINTERSTEEN, Bernice (Bonnie) McIlhenny, b. 1903. American civic worker, sister of Henry McIlhenny.
 April 1953 1
 No date 2

WINTHROP, Grenville Lindall, 1864-1943. American lawyer and art collector.
 May 31, 1909-June 8, 1939 15

WISKEMANN, Elizabeth. English historian and journalist.
May 14, 1949 1
WITT, Mary Helene. Wife of Sir Robert Clermont Witt.

March 2, 1913-May 20, 1928 2

WITT, Sir Robert Clermont, 1872-1952. English art amateur and collector, founder of Witt Reference Library, London.
December 12, 1909-January 24, 1952 38

To MB:
December 25, 1924-April 9, 1936 4

To NM:
February 1, 1951 1

WITTGENS, Fernanda, 1905-1957. Italian art historian and museum director.
December 9, 1948-December 21, 1953 3

WOERMANN, Karl, 1844-1933. German art historian and museum director.
March 31, 1894-April 8, 1894 2

WOLF, Emile E. American art collector.
May 21, 1953-September 15, 1953 5

WOLF, Gerhard. German diplomat.
May 20, 1947-October 2, 1947 2

WOLFF, Kurt, 1887-1963. Head of Pantheon Books, Inc., New York publishers.
May 13, 1924-December 13, 1949 26

WOLFF, Robert Lee, b. 1915. American historian.
December 11, 1957 1

WÖLFFLIN, Heinrich, 1864-1945. Swiss art historian.
July 15, 1903 1

WOODWARD, Norah. Daughter of English art collector.
October 25, 1950-December 13, 1955 19
No date 1

WOOSTER, Mary. Austrian-born daughter of Baron Springer, married first to French Baron Fould, then to Frank Wooster, English garden expert.
June 6, 1954 1

WORCH, A. French art dealer.
July 11, 1914-December 23, 1914 2

WORTH, Irene, b. 1916. Anglo-American actress.
January 13, 1953-February 29, 1956 10

WRIGHTSMAN, Charles Bierer, b. 1895. American financier and art collector.
November 12, 1956-November 24, 1957 6

WRIGHTSMAN, Jayne. Wife of Charles Bierer Wrightsman.
August 13, 1956 1

WULFF, Oskar K., 1864-1946. German art historian.
March 18, 1905-March 23, 1905 2

YADIN, Yigael, b. 1917. Israeli Army officer and archaeologist.
January 22, 1958 1

YALE UNIVERSITY PRESS, New Haven, Connecticut.
January 14, 1929-September 2, 1930 14

YASHIRO, Yukio, b. 1890. Japanese art historian and museum director.
January 2, 1924 -September 13, 1957 35
No date 24

To MB:
November 10, 1923-September 9, 1924 3
No date 3

To John Coolidge:
No date 1

YASHWILL, Princess Nathalie. Russian-born acquaintance associated with Kondakov Institute, Prague.
December 30, 1937-July 4, 1938 3

YATES, C. B. English Army officer.
To MB:
June 13, 1904-October 30, 1904 4
No date 1

YOUNG, Owen D., 1874-1957. American financier and government official.
July 20, 1933 1

YUGOSLAVIA, Princess Olga of. Born Princess Olga of Greece, daughter of Prince Nicolas of Greece, and wife of Prince Paul of Yugoslavia.
November 9, 1948 1

To MB:
April 15, 1936 1

YUGOSLAVIA, Prince Paul of, b. 1893. Regent of Yugoslavia, 1934-1941.
September 4, 1924-March 24, 1956 119
No date 5

cont.

To MB:
January 18, 1917-August 30, 1935 9

ZAHLE, Erik. Danish art critic and museum curator.
February 2, 1931-December 20, 1954 34

ZANGWILL, Edith. Widow of Israel Zangwill.

To MB:
August 9, 1926-February 16, 1936 3

To Alys Russell:
August 9, 1926 1

ZANGWILL, Israel, 1864-1926. English novelist and playwright.
November 10, 1900-June 23, 1924 8
No date 1

To MB:
March 13, 1920-January 22, 1922 2

ZANOTTI-BIANCO, Umberto, 1889-1964. Italian archaeologist, phil-
anthropist and sociologist.
February 1945 1
No date 1

ZELLERBACH, James David, 1892-1964. American financier and
diplomat.
April 28, 1950-April 24, 1957 12

ZEN, Carlo. Italian art dealer.
January 4, 1911-October 10, 1911 16

ZERI, Federico, b. 1921. Italian art historian and writer.
March 25, 1947 1

To NM:
January 11, 1958 1

ZOETE, Beryl de. English writer.
November 19, 1937-1958 9
No date 27
See also: Colefax, Sibyl

PART TWO

a: BERNARD BERENSON

BERENSON, Elizabeth.
August 23, 1901-February 4, 1940 40
No date 2
BERENSON, Julia.
June 26, 1912-August 29, 1938 59
BERENSON, Lawrence.
October 17, 1922-August 25, 1956 5
BERENSON, Mary.
September 22, 1890-September 17, 1944 3258
No date 7
BERLIN, Isaiah.
April 27, 1958 1
BIDDLE, Francis.
May 14, 1948 1
BIDDLE, George.
October 24, 1951-August 20, 1957 11
BLISS, Robert.
February 2, 1945 1
BOEHLER AND STEINMEYER.
May 10, 1929-March 2, 1931 2
BÖETHIUS, Carl.
April 19, 1958 1
BOOTH, Ralph.
November 10, 1922 1
BOTOND, Patricia.
September 1949-January 1958 27
BOTTENWIESER, Paul.
April 29, 1927 1
BROSIO, Manlio.
November 1954 1
CAILLOIS, Roger.
July 30, 1951 1
CANFIELD, Cass.
December 1, 1945-January 28, 1947 3
CAVIGLIA, Enrico.
January 1927 1
CHANLER, Margaret.
December 13, 1952 1
CHATTERJI, N.
July 8, 1957 1
CLEMEN, Paul.
No date 1

COLEFAX, Sibyl.
August 30, 1948 1

CONKLIN, Edwin.
No date 1

CONSTABLE AND CO.
July 15, 1946-March 2, 1948 7

CONSTABLE, William.
December 26, 1924-January 20, 1958 104

CONTINI BONACOSSI, Alessandro.
No date 1

COSTER, Byba.
July 1, 1945 1

CRAM, Ralph.
June 2, 1941 1

CURTIS, Ralph.
February 3, 1911-February 2, 1919 11

D'ABERNON, Viscount.
October 22, 1927 1

DE ANGELIS D'OSSAT, Guglielmo.
January 21, 1948 1

DELLA PERGOLA, Paola.
July 15, 1954 1

DIENEMANN, Mally.
1955-1957 7

DU BOS, Charles.
November 1906-January 1, 1937 29

DUVEEN BROTHERS.
February 29, 1912-March 1937 100

EDE, H. S.
November 12, 1927 1

FIELD, Michael.
May 3, 1890-1910 62

GARDNER, Isabella.
November 17, 1901 1

GASPARIN, Edith de.
January 3, 1937-March 10, 1958 199

GILLET, Louis.
January 11, 1909-February 27, 1943 155

GILLET, Suzanne.
June 13, 1943-April 2, 1945 4

GLAENZER, Eugene.
1904 1

GODWIN, Blake-More.
August 7, 1950 1
GOLDMAN, Henry.
February 27, 1924 1
GREG, Robert.
December 3, 1953 1
GUGGENHEIM, Solomon.
December 23, 1939 1
HAFFNER, F.
July 31, 1936 1
HAMILTON, Carl.
July 27, 1924 3
HAMILTON, Hamish.
June 28, 1951-February 12, 1958 217
HAND, Learned.
1956 1
HARRISON, Leland.
May 2, 1940-April 27, 1944 3
HATHAWAY, Calvin.
August 1948 1
HEMINGWAY, Ernest.
November 2, 1955 1
HOROWITZ, Béla.
July 9, 1954 1
HOWE, Mark.
January 17, 1954-February 3, 1955 2
No date 1
HYDE, Louis.
March 8, 1924 1
JOHNSON, Alvin.
February 17, 1941 1
JOHNSON, John.
April 9, 1917 1
KAHN, Adèle.
June 10, 1940 1
KATKOV, Georg.
June 21, 1937 1
KEYSERLING, Hermann.
1911-1920 19
KLEINBERGER, F.
February 1, 1922-July 23, 1927 18
KNOPF, Blanche.
August 17, 1954 1

KRESS, Rush.
January 25, 1947-September 13, 1953 20

KRESS, Samuel.
December 8, 1941-July 1, 1947 3

LAFFAN, W. M.
August 4, 1909 1

LAMONT, Thomas.
April 14, 1926 1

LANZ, Otto.
No date 1

LEE, Vernon.
August 24, 1897 1

LEVY, Louis.
October 11, 1927-September 20, 1940 11

LEWIS, Katherine.
November 11, 1933-November 17, 1933 2

LOESER, Olga.
December 8, 1941 1

L'ORANGE, Hans.
May 2, 1939 1

MAKRIDY, Bey.
March 27, 1930 1

MARIANO, Nicky.
July 7, 1922-August 18, 1938 209

MARSH, Edward.
July 9, 1945-January 26, 1948 4

McCARTHY, Mary.
March 29, 1958 1

MEISS, Millard.
April 1, 1947 1

MOE, Henry.
May 31, 1955 1

NORRINGTON, Arthur.
January 16, 1928-April 25, 1951 4

NORTHROP, George.
April 4, 1952-November 13, 1957 15

OFFNER, Richard.
October 23, 1924 1

ORLANDO, Vittorio.
No date 1

ORMESSON, Wladimir d'.
July 8, 1957 1

9.

OWEN, Richard.
June 2, 1928 1
PAOLINI, Paolo.
No date 2
PERRY, Ralph.
October 23, 1939-February 10, 1940 3
PHAIDON PRESS.
November 12, 1956 1
PHILLIPS, Duncan.
October 28, 1937 1
PIOT, René.
December 3, 1910-January 6, 1911 2
PLACCI, Carlo.
November 27, 1907 1
POGGI, Giovanni.
January 31, 1930 1
POPE-HENNESSY, John.
April 7, 1958-April 21, 1958 2
PORCELLA, Amadore.
February 10, 1934 1
PREZZOLINI, Giuseppe.
December 3, 1933 1
RABINOWITZ, Louis.
April 13, 1946 1
RIZZO, Giulio.
January 12, 1943 1
ROBILANT, Edmondo di.
August 7, 1928 1
ROTHSCHILD, Liliane de.
April 19, 1958 1
ROUVIER, Jean.
December 5, 1942 1
RUSSELL, Alys.
January 31, 1951 1
SACHS, Arthur.
March 18, 1928 1
SACHS, Paul.
April 28, 1921-May 8, 1946 5
SCHUSTER, Max.
February 1, 1952 1
SPRIGGE, Sylvia.
March 14, 1954-March 23, 1955 2

STEINMANN, Ernst.
 April 8, 1908-May 17, 1933 26
TAYLOR, Francis.
 No date 1
THACHER, John.
 June 1946 1
THOMPSON, Daniel.
 September 16, 1933-December 10, 1957 78
THYSSEN-BORNEMISZA, Heinrich.
 September 14, 1929 1
TOESCA, Pietro.
 January 20, 1929-July 28, 1941 4
TREVELYAN, George.
 January 19, 1899 1
TYLER, Elisina.
 No date 1
VALENTINER, Wilhelm.
 August 26, 1928-May 10, 1934 3
VISCONTI-VENOSTA, Enrico.
 June 23, 1931 1
VOLPI, Elia.
 December 27, 1915 1
WELLES, Sumner.
 September 12, 1945 1
WERFEL, Franz.
 March 26, 1933 1
WHARTON, Edith.
 April 1910-May 7, 1937 34
WOLF, Gerhard.
 May 23, 1945 1
WOLFF, Kurt.
 January 17, 1954-February 3, 1955 2
 No date 1
YALE UNIVERSITY PRESS.
 March 26, 1929-March 1, 1930 3
YASHIRO, Yukio.
 September 13, 1942 1
 No date 1
ZOETE, Beryl de.
 March 5, 1947-April 12, 1956 16

b: MARY BERENSON

ABBOTT, Senda.
 October 31, 1900-March 11, 1929 6

ADAMS, Henry.
 March 27, 1910 1

ALTMAN, Benjamin.
 July 19, 1909 1

BACHE, Jules.
 August 10, 1927-June 24, 1930 4

BELL, Charles.
 March 14, 1915-October 19, 1915 4

BERENSON, Abie.
 October 24, 1901-January 22, 1904 9

BERENSON, Bernard.
 September 6, 1894-September 10, 1944 3440

BERENSON, Elizabeth.
 June 17, 1911-December 5, 1941 10

BERENSON, Julia.
 September 16, 1914-June 30, 1935 2

BINYON, Robert.
 July 3, 1932-February 7, 1936 2
 No date 2

DUVEEN BROTHERS.
 January 29, 1913-July 30, 1931 49

FRY, Roger.
 January 28, 1900-April 27, 1916 12

GILLET, Louis.
 January 17, 1923-December 29, 1926 5

HAMILTON, Carl.
 March 12, 1920 1

KLEINBERGER, F.
 August 12, 1924 1

LEVY, Louis.
 July 26, 1924-July 14, 1932 4

LEWIS, Katherine.
 January 25, 1937 1

MARIANO, Nicky.
 November 13, 1920-November 6, 1943 241

MOORE, Thomas.
 July 8, 1924 1

OBRIST, Hermann.
 October 1, 1894-October 24, 1894 5
 No date 1

PLACCI, Carlo.
 December 23, 1917-February 25, 1923 2

ROBILANT, Andrea di.
 June 6, 1927 1

SACHS, Paul.
 May 1, 1921 1
 No date 1

STEINMANN, Ernst.
 April 22, 1913-April 12, 1932 9

STRONG, Eugénie.
 No date 1

SULLEY, Arthur.
 May 11, 1920-June 13, 1927 11

c: NICKY MARIANO

BAZIN, Germain.
 March 16, 1957 1
BERENSON, Bernard.
 June 1, 1920-December 24, 1952 207
BERENSON, Lawrence.
 June 2, 1947-1953 4
BERENSON, Mary.
 April 25, 1919-July 27, 1940 401
CONSTABLE AND CO.
 August 24, 1947-April 12, 1948 5
DUVEEN BROTHERS.
 August 1937-September 15, 1937 3
HOROWITZ, Béla.
 January 24, 1953 1
HÜRLIMANN, Martin.
 March 21, 1950 1
MARINOTTI, Paolo.
 January 23, 1956 1
MONDADORI, Alberto.
 October 26, 1949 1
NEMES, Marczell von.
 May 30, 1924 1
NERI, Dario.
 October 7, 1953 1
REBER, G. F.
 February 6, 1937 1
RICORDI, Officine Grafiche.
 February 10, 1960-April 19, 1961 4
RUSSELL, Alys.
 August 10, 1935 1
SFORZA, Carlo.
 No date 1
VALCARENGHI, Guido.
 October 4, 1956-December 1956 2